OUTDOOR *and* LOCATION
PORTRAIT PHOTOGRAPHY

2nd Edition

JEFF SMITH

AMHERST MEDIA, INC. ■ BUFFALO, NY

Published by:
Amherst Media, Inc.
P.O. Box 586
Buffalo, N.Y. 14226
Fax: 716-874-4508
www.AmherstMedia.com

Publisher: Craig Alesse
Senior Editor/Production Manager: Michelle Perkins
Assistant Editor: Paul E. Grant
Assistant Editor: Barbara A. Lynch-Johnt

ISBN: 1-58428-070-0
Library of Congress Card Catalog Number: 2001 132043

Printed in Korea.
10 9 8 7 6 5 4 3 2 1

Notice of Disclaimer: The information contained in this book is based on the author's experience and opinions. The author and publisher will not be held liable for the use or misuse of the information in this book.

TABLE OF CONTENTS

INTRODUCTION

Whether you are an established professional or just getting started, outdoor portraiture offers a professional photographer countless opportunities that are missed by many studio photographers. Most photographers start out by offering everything to the few clients they

have. They will go to the client's home or to the place a couple had their first date. In short, they will do almost anything to create a portrait that is meaningful to their client.

When a photographer's client base grows, they often give up going to locations outside the studio or studio grounds. They don't stop offering these sessions, but they price them so high that no client will pay for it; they feel that traveling to and from various locations is a complete waste of time. They figure that their time could be better spent photographing clients in the studio. While this concern has some business merit, it doesn't take into consideration the fact that profits from a session done on location are higher on average than those done strictly in the studio.

In this book, we will discuss everything you need to know about working with clients to produce beautiful outdoor portraits. We will cover both the artistic and technical considerations that go hand-in-hand with this type of portraiture—from working with natural light, to equipment selection, to posing the subject and defining your photographic style. This book also tackles the business end of photography, covering effective planning and marketing strategies for starting or improving a business and ensuring maximum profit. Taking beautiful portraits is important, but if it doesn't produce enough profit, you can't stay in business. The creative process is always easy when money isn't an issue.

CHAPTER 1

THE RIGHT EQUIPMENT

In essence, a piece of equipment, whether it is a camera, a flash, a lens, or a filter, is nothing more than a tool that is used to create a final product. When a young photographer sees one of my images and questions me about it, "What brand do you use?" is one of the first questions asked. Questions about format and exposure generally follow. To these questions, I typically respond, "Does it matter?" Would a beautiful image shot on a 4" x 5" view camera have been any more or less beautiful if shot with a 35mm? If I shot a beautiful portrait at f5.6, wouldn't it have been just as beautiful at f8?

The bottom line is that there is no magic that one brand has that another doesn't. Most of the differences between various camera lines, manufacturers, and formats lie in the "extras," the little things that make a camera feel right to one photographer or wrong for another. These differences, for the most part, have little effect on the finished product.

In a sense, the same is true of the camera settings. You must choose what works best for you in a specific situation. Let the amount of light you have to work with and the amount of depth of field you need dictate your exposure choices. If the background behind the subject needs to be softened, open up the lens to achieve the proper effect. If the background adds something to the portrait and you want to see it with as much clarity as possible, close down the lens to increase the background and foreground sharpness.

I got into photography at a young age. I did my first wedding when I was sixteen years old, and opened my studio when I was twenty. I chose my camera brands and format based on the opinions of local photographers and camera store salespeople rather than sound business decisions.

Like most young photographers, I learned photography on a 35mm. When I expressed my desire to work with clients, everyone told me that I had to use medium format. The same advisors informed me that anyone who was anyone in the business used a Hasselblad. So at the age of fifteen, I took all of my savings, borrowed money from my parents, and purchased a basic Hasselblad setup (very basic—one body, two lenses, two backs). To date, this was the finest camera I have ever used. The lenses had an amazing resolution, the camera functions were precise, and the durability was unmatched. On the downside, I spent the next five years trying to buy pieces of equipment that were priced way beyond my means.

Finally, I realized that I had to change cameras if I was to acquire the equipment I needed to run a business. Once again, I turned to the words of wisdom from the photographic community. Everyone seemed to agree that if I wasn't going to work with a Hasselblad, I'd simply have to use a 6cm x 7cm format. They explained all the advantages of the 6cm x 7cm format; the ease of retouching, the ability to produce larger wall portraits, etc. So, of course, being young and naive, I sold my Hasselblad and bought a 6cm x 7cm system.

Then two amazing things happened to me. I married my wife, Charla, and shortly thereafter found out I was going to be a father. Suddenly, the realities of life crashed down on me. I saw that my studio, which was run strictly to suit my creative urges, now had to become a business that provided a good income and a future for my child. I realized I had to learn to see my equipment as tools, not as toys.

▶ SELECTING A CAMERA FORMAT

The rules for camera format have changed over the years. Because of improvements in the film we use and the quality of today's lenses, it is now possible to produce much larger prints from much smaller negatives. There is no perfect format, only photographer's and camera manufacturer's opinions about the perfect format. Camera format should be a personal choice, and one that is made with the following points in mind.

Cost. In our studio, we specialize in high school seniors. This is a higher volume type business—we photograph almost four thousand seniors a year. The first year I switched from 6cm x 7cm to 645 (645 is used through-

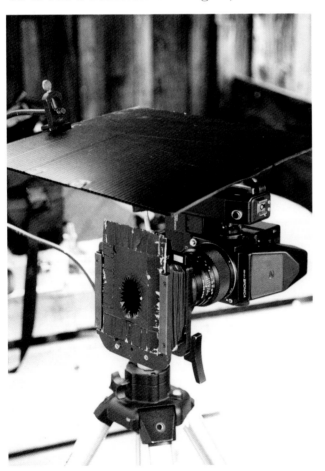

Left: This is the basic camera setup. A Bronica 645 with a 150mm lens, a Lindahl bellows shade with a handmade black vignette, Glamour Soft 2 diffusion filter, a Sailwind accessory arm with a black plastic gobo and 3036 Bogen tripod.

out this book to refer to the 6cm x 4.5cm format), I saved enough on film and processing to pay for one complete camera setup. For my studio, the 645 is perfect. Since seniors typically don't order portraits larger than 30" x 40", the negative is large enough for quality retouching, and I save several thousand dollars a year on film costs and processing. The larger the format, the more it costs your business, not just in equipment, but for the ongoing cost of film and processing. If you have a low volume/higher profit studio, the savings in film and processing costs gained from switching formats won't be that significant.

Portrait Size. Your business trends and customer needs will also influence your decision in selecting a particular format. If the largest size portrait you sell is a 16" x 20" and all you have to work with is a 35mm, you're in luck. If your clients want sizes larger than a 16" x 20" and you want to enjoy the additional profit of selling these larger size prints, you need to use a larger negative.

Clientele. High school seniors, for example, require a great deal of negative retouching, so a larger negative is needed. Retouching is possible on 35mm, but your lab will hate it. On the other hand, if you are photographing weddings or children in a journalistic style, which requires quick focusing, longer telephoto lenses and typically handholding the camera, a 35mm would be the perfect choice.

Mask Sizes. Many photographers fail to consider the business practicality of their photographic choices. The more mask sizes your lab offers for the format you use, the more freedom you have in cropping your final portraits. If your lab only offers one mask size for the format you use, you can plan to spend more for custom printing.

▶ **OUTDOOR BASICS**

A camera is just one of many pieces of equipment that are needed when you create portraits outdoors. Some of this equipment just makes your job easier, and some is necessary to produce a salable portrait.

Lighting. Whether working in a studio or outdoors, much of the equipment is the same. The main difference is that in a studio you work with flash, which freezes any motion. Outdoors, you are working with natural light, usually in shaded areas, which means lower light levels. Higher speed, finer grain films help, but you will still find yourself working with slower shutter speeds.

Tripods. The more you can do to lessen camera movement and vibration, the better quality images you will provide your clients. A very sturdy tripod and cable release are a must. If your camera has mirror lockup function, use it before each exposure is made. If you get a little vibration while exposing a 645 or 6cm x 7cm negative, you have a very embarrassing situation when your client's 24" x 30" comes back from the lab.

Lens Shades. In the studio, you have control over where the light from flash units will go. Outdoors, you often find yourself taking a portrait in which you and the camera are in direct sunlight, while the subject is in shade. The lens has to be protected from light hitting the lens. A simple rubber lens shade will help, but to ensure you will not have any flare on the final image, you should use a bellows type lens shade. These are large enough to block all light from hitting the lens and can extend out far enough to work with any focal length lens. These bellow type shades are available from Lindahl and Sailwind. (See the resources section for contact information.)

For added protection against flare, I like to use an accessory arm with a black gobo attached. While the bellows shade will protect the lens, if direct sunlight hits a vignette, diffusion filter, or goes through the filter slots of the bellows shade, flare will ruin your portrait. We purchased this accessory arm from Sailwind and it attaches to the tripod. The black gobo is just a piece of lightweight plastic we purchased from a sign maker.

Brightscreens. Focusing is another problem when working outdoors. In the studio, you have subdued room lighting and modeling lights on your flash units to light up the subject you are focusing on. Outdoors, you have a subject in a shaded area with very soft light, which produces little contrast. Combine that with a larger lens opening, producing a shallow depth of field, and it becomes very easy to get images that are slightly out of focus. In all of our cameras, we have replaced the standard ground glass that came with the camera with Brightscreens, which make focusing much easier.

Organization. You also need to double check that you are returning with everything. When I work on location, I am working with

QUICK TIP

Working in the great outdoors means that you have to plan ahead. An extra roll of film, camera back, or backup piece of equipment isn't just a few steps away, like in the studio. Whether you use a checklist or just double check everything before you leave your studio, be sure that you can account for all of your equipment. This way you can avoid embarrassment over forgetting something that is needed for your session.

several clients at a time, and in different areas of that particular location. Equipment gets put everywhere and it's very easy to leave something behind.

Since I have to work quickly to keep up with the number of seniors I am photographing, I always wear a large fanny pack. I stock this fanny pack with extra film, a back, a small container of hair spray, safety pins, handy wipes (for sweaty, shiny faces of men), and just about everything else I or my clients might need when we are far from our gear. Believe me, it saves miles of walking every year.

▶ GOING DIGITAL

Before delving into the details about going digital, let's put some things into perspective. First of all, if a business is to invest in new technology, which costs more than old technology, that business must make sure that there is a potential to increase profit to make up for the additional cost. For most studios that go digital, the decision to make the switch is based more on excitement than businesses sense.

So why would a business invest in a system that cost "only $20,000" realizing it will be worth next to nothing in three to four years? Why go digital, when output costs are higher? Why have so many photographers made the switch when up until recently it was not possible to get a quality print over 20" x 24"? Simply for the ability to produce instant previews on a monitor and the ability to easily retouch a digital file.

Many photographers think that the savings on film will offset the initial costs of digital equipment. What they don't anticipate is the time involved in managing the image files.

Unlike film that is typically shipped off to the lab, you have to download, color balance, retouch, and archive all these images, with the lab only acting as an output device. The lab can do these services for you, but most photographers will find this option more expensive than using film. Almost every portrait photographer that I have talked with (who is honest and not just excited), who has switched their studio to digital has found digital costs to be higher than film costs when time is factored in.

I, like most photographers, have been waiting for three things to happen. I am waiting for the cost of the cameras and digital output to come down, because everything is completely overpriced. I am waiting for the quality, size limitations, longevity, and feel of the final output to improve. Lastly, and most importantly, I am looking for a means to pay for all this high-cost equipment.

With the introduction of the Nikon D1 the Fuji S1 and the Canon D30, prices have finally started coming down. Even Kodak is starting to adjust prices for a new, more competitive market. Labs have also started offering lower cost outputs and printing on photographic paper to ensure a lasting image that has the same feel and look as images produced by film. Our lab offers me the same price on prints whether they are from a file or film.

For me, these advances are a start. I've had a difficult time justifying the high cost of digital equipment, knowing that the images produced would have to result in sales that paid for the equipment and earned a profit. We started by renting a Canon D30 and photographing three days worth of sessions. I then order a Template CD set from Tallyn Photo, which sells ProTemplates from Dover Digital.

We then set up template images (examples on following pages) for each of the sessions to see how marketable they were to our seniors. Based on the response of our seniors, I knew I had found a away for all this to come together, that would increase, rather than decrease our profit.

The Canon can easily produce an 11" x 14" image and we have produced many beautiful 16" x 20" images. It is easy to work with, records a true skin tone and, since we work with Canons for 35mm, we have been able to use all of the lenses we have. Working with only seniors, this image size is large enough. Many photographers that work with families, children, and other types of clients sell large wall portraits. These sizes can be produced with digital backs, which have a much higher price tag.

Digital is a subject that everyone wants to know about, but is way too complex to fully cover here. In deciding whether or not to take the leap yourself, consider the following: First, make sure it will pay for itself. If you don't have any profitable reason to switch, then don't. Second, work with the lab that will be doing your printing for you. Have them help you set up a working environment that will give you consistent results. Color management will become your first and greatest task. I suggest that you invest in a videotape series by Eddie Tap, available through his website at http://www.eddietap.com. He has been doing digital for years and has developed a comprehensive system for handling digital files.

When photographers start working with digital they have a tendency to take way too many images in a session, and to overuse Photoshop's® tools for retouching and adding artwork. As with sessions on film, set and

Andrea

While there are benefits to using digital cameras in your photography, they can easily be outweighed by factors such as the cost of the equipment and the turnaround time between shooting the image and having prints made from the digital files. Be absolutely certain that you are able to work around the drawbacks before investing in a digital system.

Patty

stick to a certain number of shots per pose because, while you may not have film cost, you have time costs. At our studio, we have standardized the amount of retouching that we will do on each image. Anything more than what we have set for our normal enhancement is billed to the client. We only retouch acne, soften the circles under the eyes, and eliminate any shine on the skin (on fair skin). A file can be ready to print in less than two minutes and many files are not retouched at all.

The only time we correct the background, clothing, or hair is when the problem is our fault or the client understands they will be billed for our time. Many photographers sell their clients on the ease of retouching that digital photography allows, never explaining it might take a person forty-five minutes to an hour to make these changes look realistic on a single file. As in any business, time is money. If you must invest a lot of time in correcting images, you will have to pass the cost for this service on to your clients.

Photoshop 6® is a powerful tool for editing image files, but it can be very time consuming. We work with the fastest processor available and 512MB of RAM. The money you spend in hardware will more than pay for itself in time. Buy the best monitor and calibration software you can afford.

Your transition to digital will be a slow process, and it should be. In business, you take small steps and not leaps. We still shoot 95 percent of our seniors on film and will continue for many years to come. We have much to learn, and it's easier learning with five percent of your clients than one hundred percent of your clients.

▶ **FILM**

The belief that one film is superior to another is more a matter of a photographer's/manufacturer's opinion than one that will result in a noticeable difference in the image quality you provide to your client. It's important to take professional endorsements with a grain of salt. After all, a photographer may tell you to use Kodak this year, and in two years, sell the merits of Fuji film.

I always used Kodak—right up until our lab started using Fuji paper. When shooting Kodak film and printing it on Fuji paper we kept seeing magenta in our whites, white drove me (as well as our lab) crazy. These problems continued until I spoke with a representative from another lab whose clients had experienced the same problems when their lab switched to Fuji paper. He told me that to get the best results and the truest color, you should use the same brand of film as your lab uses for paper. Since switching to Fuji film, we've been pleased with the color and have had no problems with color casts in our whites.

As far as the other brands go, I have tried them all and none disappointed me. The Portra Series of films from Kodak have very fine grain, exceptional color and would be my film of choice (if my lab used Kodak Paper). Just about all of the other brands can produce professional-quality results when processed by a quality lab. The one complaint I have heard about the less expensive films, like Agfa/Konica, is that the graininess of the film becomes obvious as you enlarge them to wall portrait sizes (16" x 20" to 30" x 40"). This is especially true in the higher speed films.

In the studio, we currently use Fuji NPC, rather than NPS, which is a 160ASA portrait film that has a higher contrast. Since we dif-

fuse most of our images, we always select a higher contrast film to add more snap to the image. We rate this film at ASA 100 for use in the studio.

Outdoors, we use Fuji NPH, which is a 400 ASA film that also offers a higher contrast. With the soft lighting that exists in open shade, the added contrast is needed—especially if we diffuse the images. We rate the NPH at 320. Fuji has just released 800 NPZ, which is improved over the older 800 speed film. We use the 800 speed film for very overcast days on the beach, or when sessions run over and we find ourselves still working as the sun goes down.

Honestly, film is film. If you are using a particular brand and are happy with the results, there is no reason to change. In this book there are images that have been taken on Fuji and on Kodak films and no one could ever see the difference in the quality between them. Sometimes, professional speakers will tell you to use one brand or the other, but you must always question advice from anyone who is getting paid (or sponsored) by the company whose products they are telling you to use.

▶ FROM PHOTOGRAPH TO PORTRAIT

Today's cameras are so sophisticated that even a hobbyist can produce a fairly good photograph. Using these cameras, a nonprofessional photographer can place a subject in the shade, stick them up against a tree, set their camera on automatic, and produce a decent photograph. Sadly, some professional photographers don't do much more than this when they create images for their clients. They may meter the light, rather than having a camera with an automatic setting, but there is little difference in the creative process.

Some professional photographers complain that their clients will not pay their prices or order from their proofs. The truth is, you are responsible for creating an image that a client feels is worth the price you are charging. If she doesn't order, if she doesn't think your work is worth what you are charging, that's not your client's fault, it's yours.

The Effect of the Normal Lens. In going to various outdoor locations, I have the opportunity to watch other photographers working with their clients. It's always interesting to see the equipment choices they make. One mistake I see many photographers make is relying exclusively on a normal focal length lens to create portraits.

I don't know if these photographers only own a normal lens, or whether they simply enjoy working close to their clients, but a normal lens (50mm lens for 35mm camera, 75mm for 645, 80mm for 6cm x 7cm), provides just that, a normal view of reality. It also happens to be the lens that every amateur photographer uses to produce their pictures.

Simply stated, these lenses approximate the angle of view that the eye sees. This type of lens tends to distort the face and body when used from the distance required to photograph a client from the waist up. I'm sure you know there is nothing a client likes better than looking wider than they really are.

Using Portrait Lenses. For most portraiture, you want to use a portrait lens (135mm for 35mm, 150mm for 645, 165mm for 6cm x 7cm). These lenses produce a distortion-free view of your subject, and the perspective gives a portrait a more unique look. We use a portrait lens for almost every portrait we take, whether it is a head and shoulders or full-length pose.

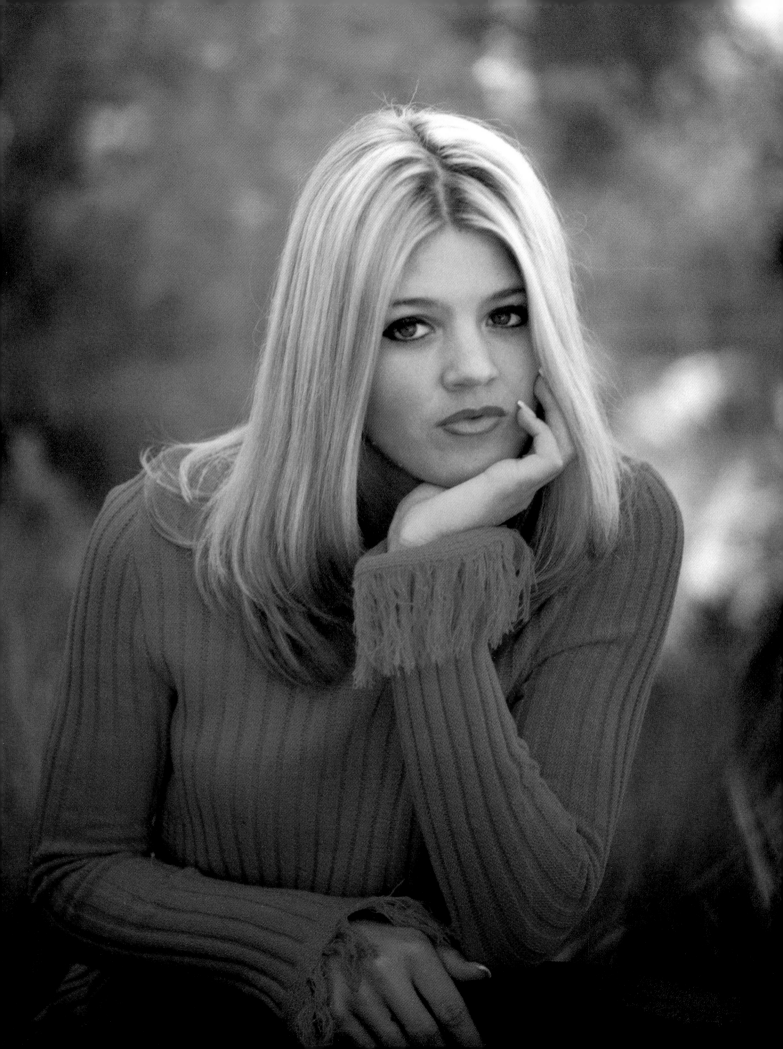

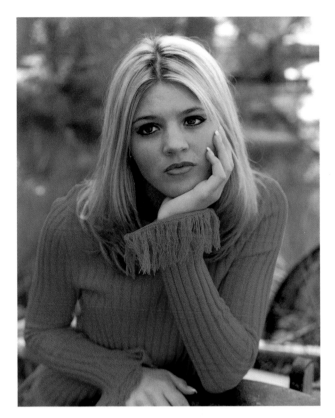

Above left: Photo taken with a normal lens. Notice the distortion elongating the nose and forehead and how the background lacks softness. **Facing page:** Photo taken with a portrait lens. There is no distortion in the face and the background has become softer. The focus of the portrait is the person and not the background elements. The same f-stop was used for both portraits. **Above right:** Setup for these two photos.

Portrait lenses offer a solution to an age-old dilemma: how can a two-dimensional canvas (or, in our case, a piece of photographic paper), record a third dimension? In a typical portrait, you have a foreground that leads into a subject, a subject in critical focus, and a background that recedes farther and farther from the subject. While the depth of field produced by a normal lens is too great to capture the relative changes in distance from the foreground to background, a portrait lens records the elements in a composition differently. With a portrait lens, the elements are completely out of focus near the camera and get progressively sharper as they approach the subject. The subject is in critical focus, and the background elements "fade out," gradual-

ly losing focus as distance from the subject increases.

This very desirable effect is produced by a telephoto lens, and can be magnified by using a longer telephoto lens if a scene calls for it. Many times, you are forced to create an outdoor portrait in a scene that is less than scenic. We have this problem with seniors who want outdoor portraits in the spring. They can't wait late enough in the spring for all the foliage to become full because they want to mail out wallets with their graduation announcements. We end up outdoors in the middle of March when the trees and other foliage have just started to get their leaves. A longer telephoto lens helps soften the hard look of all the nearly-bare branches.

Using a longer telephoto lens can work wonders. The basic rule is: the fewer choices a location offers for backgrounds, the longer focal length lens you should use. We used to use the foliage around the grounds of our studio for simple head and shoulders portraits. We used a 150mm for these portraits because we had many usable areas. However, all of the large trees and most of the existing foliage surrounding my studio were recently removed because it was causing problems with the sidewalks and foundations. Now that almost everything is gone, we use a 250mm on the 645—it softens and disguises unwanted background and foreground elements.

Working with Wide-Angle Lenses. Not all of our portraits are taken with a telephoto or portrait lens. When we feel that a background will add interest to a portrait, or is so large that a telephoto lens wouldn't produce the

QUICK TIP

A longer telephoto lens can even turn grass into an interesting background. Position your subject so that he or she is lying directly on the grass. The grass becomes both the foreground and the background in the composition, and the limited depth of field captured with the lens creates an interesting portrait.

This portrait was taken very early in spring because this senior needed to get her wallets out in her announcements. With few leaves on the trees, I used a 250mm lens to soften the little greenery that was there.

Don't overlook using the ground to pose your subject. Tall grass, logs, and other natural elements can be interesting backgrounds with the short depth of field created by longer telephoto lenses.

proper effect, using a wide-angle lens (24–28mm for 35mm, 40mm for 645, 50mm for 6cm x 7cm) is a great option. The wide-angle lens produces a much different look than a normal lens would. The distortion is greater than a normal lens, which makes for an interesting perspective. Some professional photographers, like Al Gilbert, have even gone to the extreme of using a fisheye lens to produce some remarkable portraits.

QUICK TIP

When it comes to using extreme telephotos or wide angles, use them sparingly. A client's session needs a balance of styles and looks to be successful. To put it in other terms, if your client's session was a meal, a portrait lens would constitute the complete dinner, while the portraits taken with a wide angle or extreme telephoto lens would be considered the dessert. If you try to make a meal out of dessert then your client won't pay the bill.

A wide-angle lens provides tremendous depth of field, which, in some portraits, really adds to the feeling of the image you are trying to create. Do you need to see the background and/or foreground with as much detail as possible to achieve the feeling you are looking for? Or can you focus the attention of the viewer on the subject, reducing the background/foreground down to a point that you just capture the essence of the scene? When selecting the lens for a particular portrait, consider the feeling, the story you are trying to tell, the story your client wants told. Let your creative vision determine whether you use a telephoto or wide angle.

While selecting the wrong lens for portraiture is one of the most common mistakes photographers make in creating portraits, it is not the only one. While many photographers know how to create beautiful images, when it comes to shooting outdoors, they just lean their subject against a tree, take a meter read-

ing, and feel their job is done. Some of my seniors have brought in proofs from other studios, and I have seen the work of many different photographers in our area. Many of these photographers don't generate the quality of work I know that they are capable of producing.

Perhaps this problem stems from a photographer's lack of desire to work with a particular type of client. Many photographers will go the extra mile and pay attention to every detail when it comes to a test session or an attractive client whose image they know they will be able to use as a studio sample. When it comes to working with an average or not-so-attractive client, the urge to produce an outstanding and artistic image is replaced by the mundane job of creating a picture and getting the session over with.

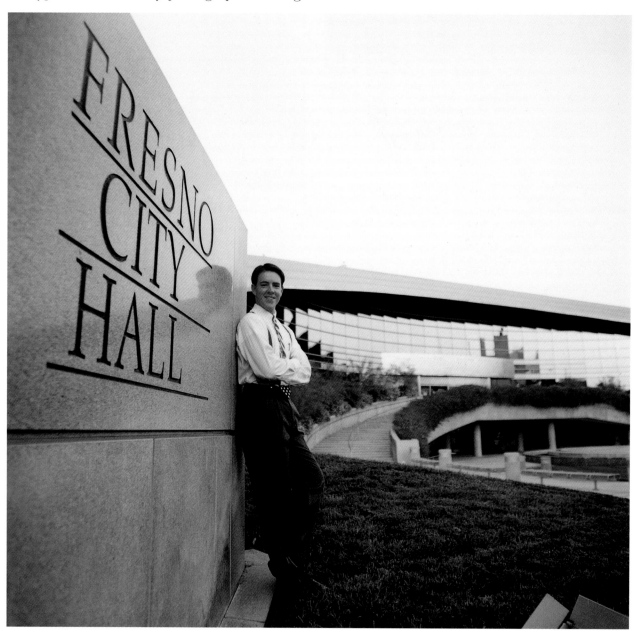

In the photo above, the sign in the foreground was important to tie in the city hall building in the background, so a 40mm lens was used. The exposure on was 1/60 second at f8.

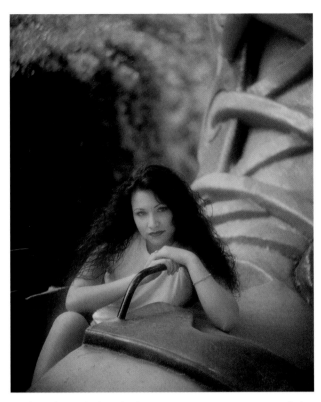

In this photo, I decided to just capture a portion of the big shoe to ensure the subject would be large enough in the frame, so a 150mm lens was used. The exposure on was ⅟₆₀ second at f8.

Unfortunately, this happens much more than most photographers think. There are many photographers whose work is comprised of nothing but "photographs." Of course, these photographers expect their labs to turn their "photographs" into "portraits." Any lab owner can tells you stories about what their clients expect them to produce from the poor-quality negatives they were provided.

A lab should only have to provide you with negative retouching and automated printing. As a photographer, I take pride in the fact that I am the creator of my work and I don't need the help of my lab or an artist to render my work valuable. Here is an important truth: if it isn't on the negative, it's going to cost a great deal of money to have it added to the print. Custom printing and artwork is not cheap.

Adding Vignettes. As I've mentioned, I'm a firm believer that a negative should contain all of the details that you expect to see in the final print. In getting everything I want on the final print right on the negative, my clients receive proofs/previews that truly show them how their final portraits will look. A basic tenet of the photography business is this: the better the previews you present to your client, the larger the sale. If you have to explain how a preview and the final portrait will differ, your average sales will suffer.

For this reason, when I shoot portraits, I like to use vignettes. Vignettes hold the viewer's attention by blending the lines that lead out of the frame. I use black for low key scenes and crackled clear vignettes for higher key images. I completely avoid using milky white vignettes when working outdoors. You want the vignette to blend and work with the tones of the portrait, and using a milky white vignette outdoors puts a light border around a medium to darker tone photograph. Remember that a viewer's eyes are always drawn to the area of greatest contrast in a portrait. Make sure that the type of vignette you select leads the viewer's eye to the subject, not the vignette effect.

Premade vignettes come with any of the more popular bellows lens shades. You can also cut the vignettes yourself. The problem with premade vignettes is they only have one size of opening, which is usually right in the center. The thinking is that you can move the vignette up and down, as well as side to side, because they come with magnets attached to them that fit to the front of the bellows shade. To increase the effect of the vignette, you have to extend the bellows shade out farther from the lens.

Well, this works fine unless you choose to add diffusion or stop the lens down. In either case, if you are using a vignette with the bellows extended, the teeth of the vignette start to show on the negative. The subjects look like they are about to be eaten by a shark.

Vignettes are made in different sizes using different materials. Outdoors, black is most often used. The crackle clear vignette blurs the edges to achieve a dreamier look.

For this reason, I like to make my own vignettes. I can cut them as small as I need to so I can work with the vignette pulled in close to the lens and avoid this problem. All you have to do is cut out the plastic from the side of a water or milk container and fit it into the vignette's slots on your bellows shade. You can also attach magnetic strips if it works better with the bellows shade you have. Next, draw an oval in the area of the frame you want to vignette. Use an X-Acto® knife to cut a zigzag pattern across that line to form the teeth. The longer the teeth, the more gradual the effect of the vignette will be. Paint the vignette matte black if you are going to shoot a low key image. For high key images, I use clear crackle vignettes, and buy the uncut material from Lindahl. (See the resources section for contact information.)

The Benefits of Diffusion. With the resolution of today's lens, an undiffused portrait is way too brutal for most clients' skin. I don't want to see every pore and every line, and neither does my client.

I diffuse portraits of both men and women. When I learned the basics of photography, I was told that men's portraits should never be diffused. After all, men's lines and wrinkles give them character. That was then, this is now. We live in a time when about one third of all the cosmetic surgery done is performed on men. Men don't want to see lines on their face any more than women do. Diffusion also "clears up" acne, which men are actually more prone to than women.

I use the Glamour Softs by Sailwind; their diffusion effect is similar to that of Zeiss Softars, but when we began using diffusion filters, the Softars were only available in a screw-in mount. Glamour Softs are 3" x 3" filters that drop into your bellows shade. This shade is a must when focusing outdoors.

Softars, Glamour Softs, and a few other quality diffusion filters produce a "clear" rather than "foggy" diffusion effect. They soft-

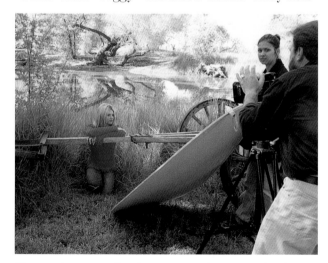

This is the setup for the images shown on the facing page.

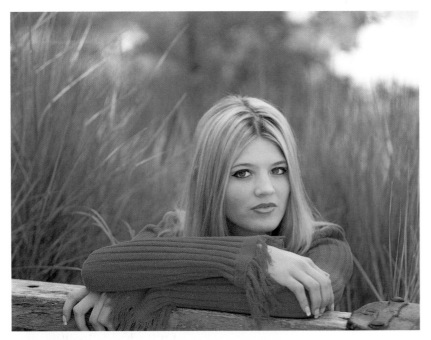

This photo was taken without a vignette or diffuser, and the result is less than professional.

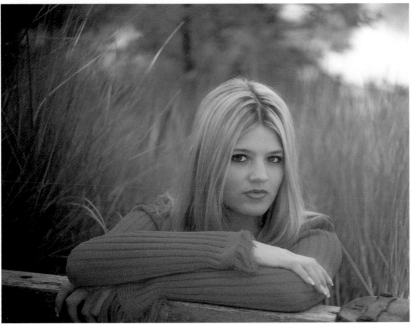

To finish the look, diffusion is added to this photo.

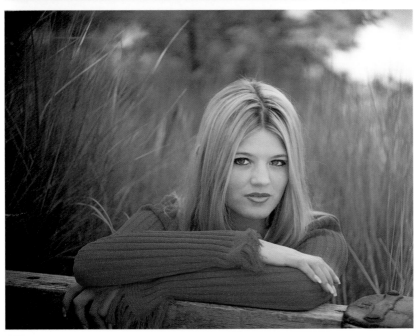

By adding a vignette, the background becomes usable and the focus is the subject, not the glowing background.

en a portrait without eliminating detail in the image. These filters are expensive, but well worth the money spent. The cheaper diffusion and fog filters typically produce a photograph that lacks all detail, especially in the eyes.

Since I work in shaded areas, I also use an SRUV filter, which is also available from Sailwind. Some photographers prefer the Singh-Ray, while others let the lab print out the blue cast that is present in the light in shaded areas. (See the resources section for more information on these products.)

QUICK TIP

In full-length poses, diffusion is not necessary in every portrait. Because the subject's facial size is recorded smaller in these images, any imperfections of the face are less noticeable.

▶ FINAL THOUGHTS

In the following chapter, I will discuss additional equipment that photographers may find useful in creating outdoor portraits. At this point, however, I want to offer a few final thoughts on equipment: The equipment that I have discussed is very basic. I don't think a photographer needs to have every gadget known to man to be able to produce a salable portrait. Many young photographers use gadgetry in place of creativity.

Looking back, I can honestly say that, because I had to start out my business with a limited amount of equipment, I learned how to improvise, to think on my feet, and to come up with alternatives and practical solutions for the challenges I faced when working with my clients.

I will never forget when I was out at a location with a young photographer who had just started working at our studio. I looked at him and asked where the light meter was. His face went completely white. He said that he forgot it at the studio. He was really in a panic because we were at a location that was about an hour away from the studio. He asked, "What do we do?" I looked at him and said, "Our sessions." How many times do you need to meter a shady area on a bright sunny day to know that it will meter $1/125$ second at f5.6 with 400 speed film? I don't advise exposure by guess, but if you are forced to figure a way around a problem, you can. This young man never had to shoot photographs without owning a light meter, but I had.

UNDERSTANDING NATURAL LIGHT

In the studio, we have complete control over light. We control the type of light and its direction by the types of light modifiers we select. We can make the light softer or more contrasty. We can change the color temperature, angle, and elevation. In the studio, light is about control and placement.

Dealing with natural light outdoors requires "seeing." Certain scenes and times of the day create more usable light for portraiture than others. In outdoor photography, understanding lighting is the first step in controlling it. You have to know what is producing the light, its direction, quality, and lastly the quantity of the light that will be acting as your main light source.

Main light may come from open sky in a scene, or it might be provided by direct sunlight reflecting off of a nearby building. While both of these sources create a usable source of main light, you must be aware that the differences in contrast, angle, and amount of light from the two light sources will provide a different look in the final portrait.

▶ **THE PERFECT LIGHT**

The same is true for the qualities that natural light possesses at different times of day. The light that exists just after sunrise and just before sunset is considered perfect for portraits. The color temperature of the light is warmer, which provides a slight color cast that creates a warm, natural look to outdoor portraits. Since the sun is very low in the horizon, the light is softer because it has to filter through the atmosphere and smog to reach your subject.

Light at this time of day is the simplest to use. At sunset or sunrise, the direction of the sun is where your main light source is, the opposite direction will provide the shadow. Since the sun is low on the horizon at these

times, it serves as a backlight, filtering through the foliage behind your subject. Open sky is your main light and both are at an intensity that work well together. If you chose to shoot this scene at midday, the open sky would provide a main light source two to five stops less than the sunlight hitting the background and acting as a backlight.

Nature gives you just about all you need when you work with this light. All the reflectors, gobos, and other equipment you need to balance the light on the subject with that of the background during midday really aren't needed at this time.

The Downside. There are two problems with working at this "perfect" time. First, this "sweet light" only lasts a short period of time before it becomes too intense or too dark. You only have time to complete session using this perfect light, your client ends up with a very high sitting fee. Also, in order to take advantage of this light, your client is forced to get up at 5:30 a.m. or stay out into evening. You have two options here: you can sell your clients on the benefits of using this light so they will pay a higher sitting fee and go out at a time that is inconvenient, or you can learn to use the light that exists the rest of the day.

▶ WORKING WITH MIDDAY LIGHT
Light during the midday hours isn't ideal. In fact, there are many reasons why it isn't ideal: The sunlight comes from directly overhead and is intense. You have light bouncing off of everything. Your main light comes from different directions with the same intensity. Your main light tends to come from too high an angle, and the color temperature of the light in the shaded areas in which you must work has a bluish cast.

Knowing all that, you're probably asking yourself why anyone would take outdoor portraits at times when the perfect light doesn't exist. The answer is that photographers are businesspeople, too. As a businessperson, I must work with my clients at times when they feel it is convenient. Because I am a professional, I have chosen to learn how to create beautiful portraits throughout the day.

About 95 percent of the portraits in this book were taken between 10 a.m. and 5 p.m. We typically schedule our outdoor sessions during this period. In fact, many of my most beautiful outdoor portraits were taken at high noon, a time that photography students have traditionally been told offers the worst light of the day. Fortunately, experienced photographers know that there are many ways to make midday light work to their advantage. In the remainder of this chapter, I will explain how photographers can use natural and architectural elements of a scene to control light. In the following chapter we will shift our discussion to the role of equipment in controlling natural light.

▶ SPOTTING A SCENE
The location that you select will determine how many usable areas there will be throughout the day. The older and more grown the foliage in a natural setting, the taller the buildings in an architectural one, the larger the shaded areas. In working with midday light, it is important that you note the following relationship: the more shaded areas available, the greater the number of salable images you can create.

Natural water areas, like rivers, often provide the best locations for outdoor portraits because of the large trees and dense foliage.

When looking for a great setting for your portraits, search for one that isn't manicured. A natural area has foliage growing at all levels that will block the sun all the day. While manicured gardens might have tall trees, the area between lower branches and the ground tends to be bare, leaving the skyline or unwanted objects visible in the background.

Similar rules apply when selecting an architectural setting for urban outdoor portraits: the taller the buildings, the more shaded areas you have to work with. Covered walkways, patios, or courtyards can also provide a usable portrait area throughout the day.

When working outdoors, you generally work with an enormous main light source—the open sky. The studio equivalent of this type of light source is bouncing a flash off a huge, white wall close to the subject. With this type of main light in the studio, you would need to place gobos around your subject to create the proper highlight and shadows for portraiture. You would have to reduce the size of the light source in relationship to the subject to have a workable light. Outdoors, you must do the same thing. Fortunately, nature provides you with everything you need to create a beautiful portrait—you just have to know what you are looking for.

▶ WELCOME OBSTRUCTIONS

The first thing you need to look for is an obstruction that will correct the angle of light that is illuminating your subject. An overhead obstruction will not only block the overhead light from the open sky, but will lower the angle of light striking the subject until beautiful catchlights appear in the eyes.

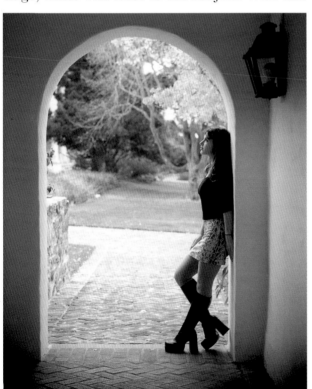

Look for areas outdoors that will block a portion of the light coming from overhead. This will allow for the sky to be used as your main light, and will also create beautiful catchlights in your subject's eyes. Be sure not to position your subject too close to the overhead obstruction, however, or it will negatively effect your catchlights.

To redirect the direct overhead light, look for a scene with tree branches overhead, or place your client under the overhang of a building. Most photographers place the subject too close to the edge of this obstruction. This blocks the overhead light, but doesn't lower the angle of light from the open sky enough to create beautiful light. In this case, all you need to do is have the subject back up and go farther underneath the overhang. This will lower the angle of light and create the lighting effect you are looking for.

There are some scenes that do not require use of an overhead obstruction. When the open sky is providing your main light, the light coming straight down on the top of the head is the same intensity as the light illuminating the face, which creates the problem. If the main light source is not the open sky, and it has more intensity (at least two stops), the light coming from overhead will not be noticeable.

At most of the locations around the studio, the main light is provided by direct sunlight being reflected off a light gray building, so the little bit of light from overhead is overpowered by the main light.

The Importance of Shadow. As mentioned earlier, photographers are constantly seeking to create a three-dimensional feeling in an image. Light alone cannot create a three-dimensional image; in fact, dimension in a portrait is created by the range of highlight to shadow and the gradual transition from one to the other.

Light is the photographer's paintbrush, according to those who teach young photographers. This is true, as long as we are working on a darker scene. However, in a lighter scene our paintbrush is actually shadow. This is because our eyes are drawn to contrast, the difference between light and shadow. In fine portraiture, shadow is just as important as light, darkness just as important as highlight.

When working in the studio, we must fill the shadow area so it doesn't record black. When working outdoors, we must find an

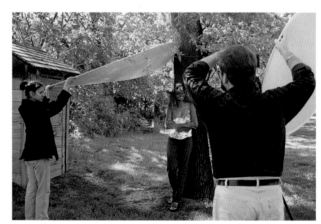

When a subject wears a hat, the brim of the hat extending out over the face is like a mini gobo, creating a shadow over the eyes. By adding light from a lower position, you can fill this shadow and create beautiful catchlights in the eyes.

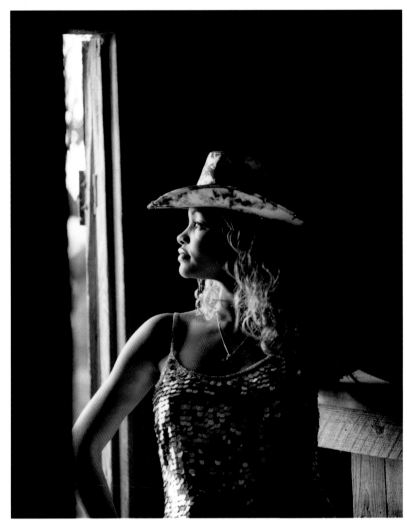

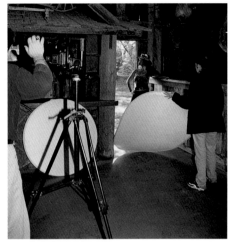

Left: A doorway provides a great opportunity for a profile shot. The light is directional and controlled by the size of the door opening. Doorways and gates symbolize the beginning of a journey, which adds a nice feeling in portraits taken in profile. **Above:** The setup for this portrait.

obstruction that blocks light from hitting one side of a subject to create a shadow. This obstruction can be the side of a building, a grove of trees, or the large trunk of a tree.

Creating shadow is essential. Without sufficient shadow, portraits appear flat and lack depth. While a subject's face will appear wider than it really is when an image lacks shadow, using shadow slims the human form, which is something your clients will enjoy.

Outdoors, most of the backgrounds are darker during the times of ideal light (just after sunrise, just before sunset). During midday, however, backgrounds range from near-black to near-white and every shade in between. At midday, then, shadow becomes

just as important as light, and light colors of clothing become just as important as dark.

The Ratio of Highlight to Shadow. There is no magic ratio between highlight and shadow. Some photographers work with a 2:1 ratio, some with a 3:1. I work with what looks good. The ratio between highlight and shadow will be different for every color of skin and each person's facial structure. Light-colored skin reflects more light than darker skin, so the ratio of light would be very different. Diffusion will also make a difference in the ratio of lighting. If the perfect ratio of light for a person's skin tone and facial structure were 3:1, which is the main light reading 1½ stops more than the shadow, you would need to change the

ratio to a 4:1 with diffusion to achieve the same effect.

Using negative film (as most portrait photographers do), you must expose your film to ensure the shadow area of the portrait will record and not just fade to black. I select a scene and visually get the light and shadow on the face the way it most flatters the subject. Then I meter the highlight and the shadow to make sure there isn't more than two stops difference between the two, which is a 4:1 ratio because I diffuse most of my portraits. Then I set my camera to overexpose the highlight by one stop.

It is important to remember that negative film can produce a printable image when it is up to three stops overexposed, but can only be underexposed by a stop and a half. By overexposing the main light by one stop, both the highlight and shadow fall into printable levels. Being able to see light and shadow the way your film will record it takes some practice. Our eyes look at an entire scene. On the other hand, film takes in the background, the foreground, the subject and every other detail in view. Film takes in so much—it records many subtle changes in lighting and shadow that go unnoticed by your eyes.

You can train your eyes to take notice of slight variations of light. When you first started creating images, you would take a portrait that your eyes told you looked great. It wasn't until you got the proofs back that you saw the awkward way the subject placed her hands, or that your subject's clothing wasn't laying properly and her white socks were beaming out of a dark pant leg. In time, experienced photographers can learn how to scan a subject from head to toe and see every imperfection. They can also learn to see the way subtle

changes in light and shadow will be recorded on film.

The Size of the Main Light Source. The third and final obstruction used to create an image outdoors must control the size of the main light. When we use a large white wall in the studio to produce our main light, the light will have no direction, be too soft and not provide a usable shadow. When shooting outdoors without anything to reduce the size of the open sky or other main light source, the same difficulties arise.

To gauge how much of the main light source needs to be obstructed, look at the size of the light source in front of your subject. Most people are easily confused when estimating degrees and angles. To simplify this part of the lesson, remember that you want a light source that has obstructions to reduce the light source down to less than 90 degrees (or ¼ of a circle, which has 360 degrees).

Here's an example to illustrate my point: if you could draw a straight line out from your subject's nose, and the nose pointed to one edge of the main light source, a full 90 degrees would mean that the main light extends from the nose to another imaginary line that comes

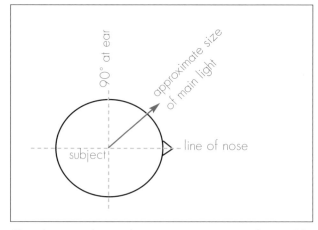

This diagram shows the approximate size of a usable main light source.

straight out from her ear. This main light source would be too large.

A workable main light, on the other hand, would have one edge starting at the line of the nose and would extend around the face to a line that extended out from about the cheekbone. This is an approximate angle. Sometimes you will work with a main light source that is smaller or larger than this. With this starting point, you can look at the main light source of a scene and anticipate whether it will work or needs to be modified.

Unfortunately, you won't normally find the perfect lighting situation when you are working with midday light. Any spot you select will probably be missing at least one—if not all—of the obstructions needed to produce a sal-

able portrait. Ideal lighting at this time of day usually only exists directly under a tree. This leaves you with limited options. At this time of day it's a trade-off: you can use the few spots that have ideal lighting, or you can learn to modify the existing light. Before we discuss light modification equipment, there is one more portrait element that is greatly effected by the natural light that exists in a scene.

Our eyes are drawn to contrast, not light. Imagine this: you have a fair-skinned, blond-haired model and ask her to wear white pants, white socks a black shirt. You put her against a white background in the studio (see above). Would your eyes go to the light areas or the black shirt? Which is the area of greatest contrast in the portrait? Now, imagine you have

Left: Fair-skinned, blond-haired model in white pants, white socks and a black shirt. Photographed against a white background in the studio. **Right:** Fair-skinned, blond-haired model in white pants, white socks and a white shirt. Photographed against a white background in the studio.

Bottom left: In the middle of the day, a background can either burn up—with the direct sunlight hitting it—or appear blotchy, with areas in direct sunlight and other areas in shade. **Left:** The closer you compose the portrait, the more it will soften the background and the more you can isolate the best area in the background. **Bottom right:** The setup for this shot.

the girl change into a white shirt. This makes the exposed skin the darkest area of the portrait and where the eye is drawn. This shows that our eyes are drawn to contrast, not light. It also gives you an idea of how to coordinate the clothing and background to make the subject (not the clothing) the focus of the portrait.

▶ THE BACKGROUND

You have found a scene that provides your subject with a usable main light source, an obstruction that blocks the light from directly overhead, and even one that creates shadow. These are the basics, but there is one additional important element for lighting a portrait: the background.

I have chosen to discuss the background in this section on lighting because, as you will see, the lighting on the background determines if that background is usable or not. Anyone can spot a beautiful scene that would create an interesting background for a portrait. But if the light on that scene isn't right, the look of the background will be completely different on film than it appears to your eyes. Because it makes up so much of the surface area of a portrait, selecting a proper background is extremely important. Views about backgrounds have changed over the years. Some photographers believe that a background must be as simple and bland as possible to ensure that it won't draw attention away from the subject. Here we have the photographer's ego at work. Forget about what the client wants. Don't worry about what the current trends and styles are in portraiture. "This is the way I was taught and this is the way it should be!" It's a bad way to look at things—if you want to make a living.

The background of a salable portrait needs to be interesting. It needs to have depth, beauty, and give the portrait a life that extends beyond the boring "Old Masters" backgrounds and simple foliage of leaves and greenery that drops off to a wall of green, which so many traditional photographers think is appropriate.

Let me remind you of an important fact: A client won't pay a premium price for an ordinary product. Professional photographers must charge more for their work because they supposedly work with fewer clients and produce a higher quality than the mall or department store photographers. But to tell you the truth, if I were some of the pros that come from the old school, I would be scared. Each year the mall and department store photographers make improvements to what they offer to their clients. They listen to what their clients want and they move in that direction.

What separates us from them is our ability to create a work of art rather than a virtual road map of the human face. But for those tradition-bound pros that refuse to change, you have to remember: we have nice lighting, they have nice lighting; we have painted backgrounds, they have painted backgrounds; you have your favorite tree with simple foliage, giving your backgrounds the look of a green wall, they have lithos and projection systems that give their backgrounds (even though they are done inside the studio) some depth and feeling. So if you were a client, why would you spend more to go to your studio again?

In watching photographers work with their clients, I've noticed that most of them have old standby scenes. Although a particular park has acres of scenes that offer a wide variety of backgrounds, these photographers stay in their little area, producing portrait after por-

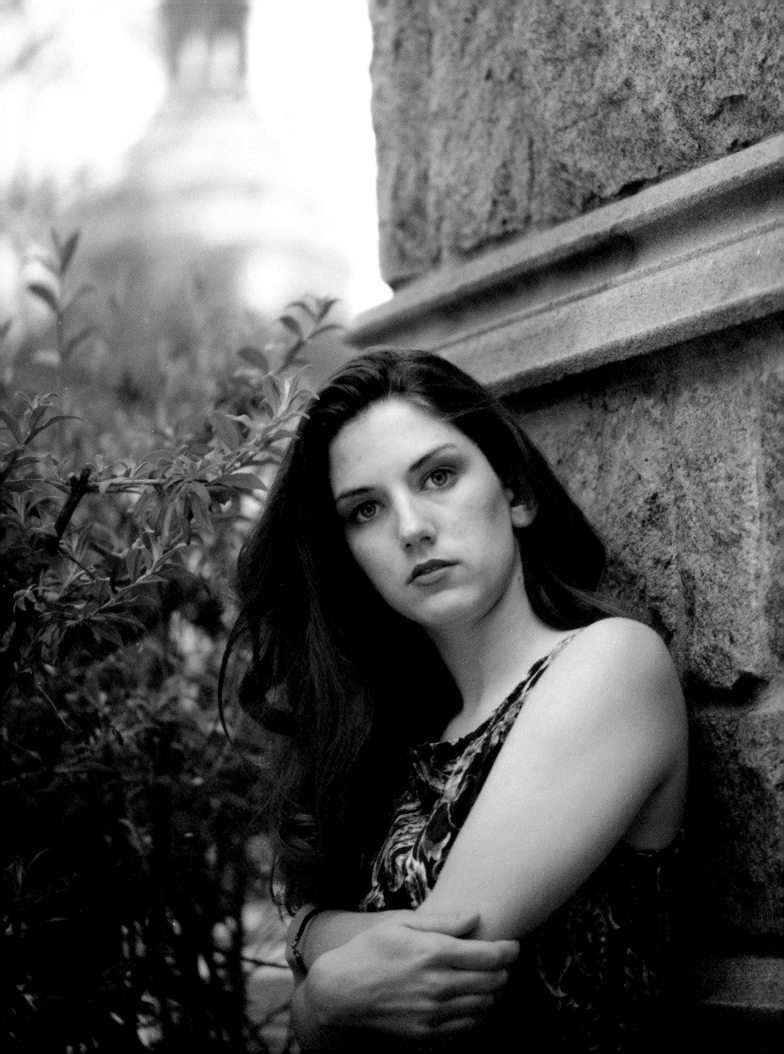

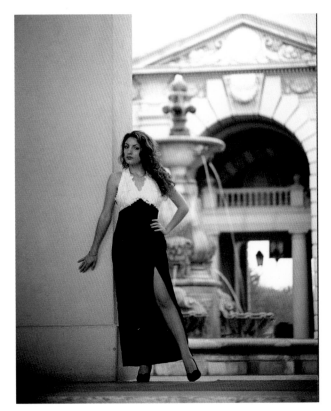 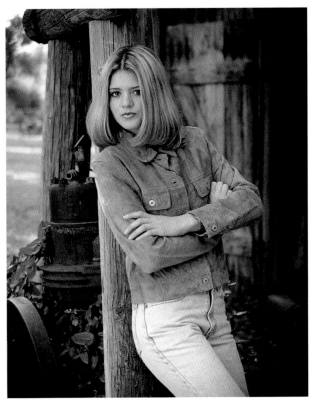

Above and left: Foliage can always make for a natural background, but keep your eyes open for other opportunities. Unique buildings, small bridges, archways, and fences can all create unique portraits that other photographers would never think to use.

Facing page: This background combines the use of foliage as well as buildings to create an interesting portrait.

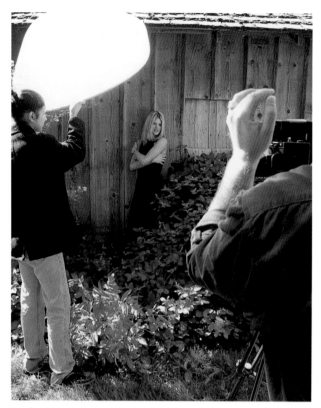 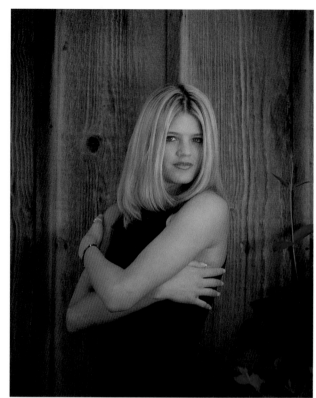

Left: The camera is positioned to take a portrait straight on. **Right:** This produces a very flat background.

trait with almost identical backgrounds. The variety of backgrounds is one of the most important options you offer to your client. Don't sell yourself short by relying only on old standby locations.

When searching for the right background for your client, you must look at several scenes and get a feeling for what each background conveys. Look at the size of the leaves, the amount of wood that is visible in relationship to the greenery, the depth of the foliage. Whatever you do, don't just look for greenery or foliage. Look for wooden or brick fences or buildings, columns, arches, ponds, and anything that is available to create an interesting background that provides your clients with more options to select from.

The background possibilities that exist outdoors are really without compare. Natural beauty exists in every park, river, and field. As

well as Mother Nature's best, you have man's most monumental structures. With all that is available outdoors, it's a wonder that more photographers don't have a studio and work outdoors exclusively.

During the ideal times of light, try this little exercise: Close your eyes, twirl around, and open your eyes. I'll bet you will be facing a usable portrait background—they are all over! At this time of day the light is soft, and the shadows of the background are elongated because of the angle of the setting/rising sun.

When an educator goes to a location during ideal lighting times, it's like cheating. Anybody can create beautiful work in these lighting conditions, and you know the only reason that the photographer has someone to photograph is that the model is getting paid to be out at 5:30 a.m. I want to provide you with practical solutions that not only work on test sessions,

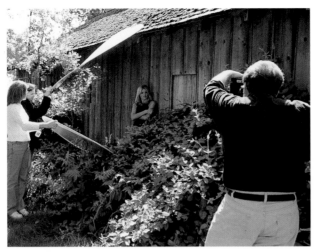

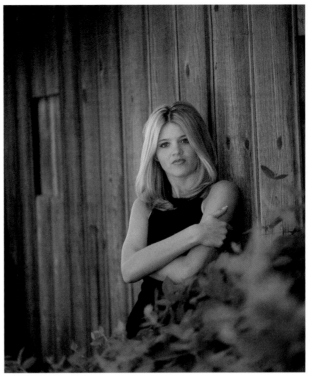

Above: The camera is moved closer to the barn wall to use the barn as both the foreground and the background. This is called skimming. **Right:** The result is an increased appearance of depth.

but on each session in the real world. For this reason, I must share a little truth with you: Selecting backgrounds at midday is not difficult, just challenging. First, you have direct sunlight filtering through even the thickest foliage, creating distracting sunspots on the background without diffusion, to glowing spots with diffusion. While the soft filtered sunlight, coming from a low angle, brings out the beautiful translucent green of the leaves during ideal shooting times, midday light comes directly from overhead. The sun beats down on the leaves, making them seem very dark, with very large highlights on each one. When working during midday, you will find yourself in need of two different types of backgrounds. In mid-morning and mid-afternoon, you look for a tall grove of trees, large buildings, or dense foliage that will block the sun from one side or the other. Most locations are either morning or afternoon spots. A grove of trees, foliage, or buildings that have access to

the east side will block the sun as it is setting in the afternoon. Areas that have access to the west side would be better in the morning hours because they block direct sunlight from the east. There are some locations that offer access to both sides of a grove of trees, foliage, etc., so they offer usable backgrounds through most of the day.

For the hours that the sun is directly overhead (noontime hours), look for a canopy type background, such as trees or buildings that you can shoot underneath. Typically, photographers think of huge trees or the covered patios of a building as the only locations available to them at this time of day. Low foliage can also be used for midday cover, you just need to lower the subject to ground level to use it.

I have heard many young photographers talk about photographing on a day that has hazy sun from cloud cover. They've read too many amateur 35mm film wrappers. I've

found that when there are clouds, it usually rains—not to mention that high winds usually accompany those clouds. When it is foggy or overcast, colors, including skin tone, don't record with their normal vibrancy. While some of you may be lucky enough to live in an area with rainless clouds or in the valley where it is always "cloudy bright," the majority of us in the real business world just can't count on that.

When I am working outdoors during the day, I use two different techniques for creating usable backgrounds with the less-than-perfect lighting that exists. I call the first technique "skimming." To use this technique, find an obstruction that has a flat side, whether it is a brick wall, row of columns, or a grove a trees. Rather than taking the shot straight on (using the wall, columns, or trees as a background that is very flat and lacking in depth), angle your shot, placing the camera closer to the obstruction.

This does many things. First, it creates a background that is illuminated with the same intensity of light as your subject, so the colors are rendered in your portrait as they appear to your eye. Second, the obstruction creates

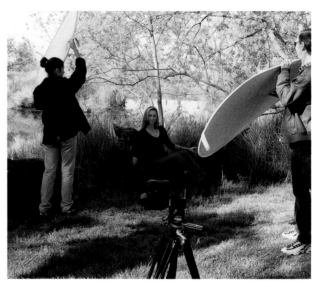

Above: To conceal the water (which the midday sun would make very bright), we line up the shot using the shaded side of the grass across the water instead. **Facing page:** The resulting portrait.

shadow for the side of the face. When these conditions exist, you create a portrait with depth. The viewer's eye starts at the foreground, which is provided by the area of the wall or trees in front of the subject. This area goes from being completely out of focus and then gets sharper the closer to the subject it gets. Then you have a background that recedes farther and farther from the subject. Skimming results in a much more appealing use of an obstruction.

I call the second technique "lining up a shot." While skimming can create simple backgrounds that have some depth, they are by no means scenic. When you line up a shot, you place the subject in a shady area, then line up the angle of the shot and use another shady area that is far away for your background. This creates a more scenic look and much more depth than skimming.

In lining up a shot, you just don't move the camera from side to side, but you can also elevate and lower the camera angle to find the

QUICK TIP

Although you wouldn't want to photograph a large family at high noon, you really don't have to. Family sessions are typically much more expensive than senior portrait sessions. Between the higher sitting fee and the additional profit earned from sales of larger wall portraits, you can afford to schedule family sessions during ideal lighting times. Family portraits take a great deal of planning for the family, so they are more understanding about unusual session times.

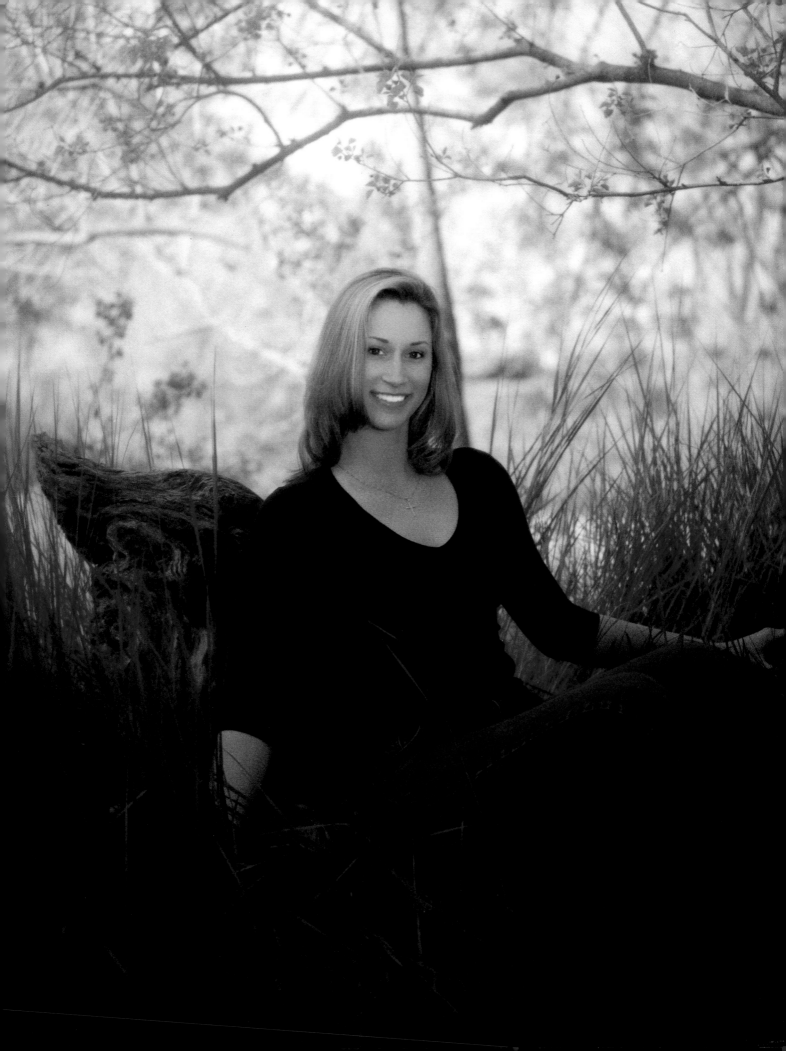

perfect background. Shooting at an angle higher or lower than a normal position works well, as long as the face is raised, lowered, and/or angled to put the plane of the face at approximately the same angle as the plane of the lens. Once the face is on the same plane, you may decide to raise or lower the chin for the effect you want.

These two techniques can be used together to create even more depth. By skimming, you can angle the shot and create depth in the foreground and background, and by lining up the shot, you can include distant foliage or another building that is illuminated with light of the same intensity as the subject.

The number of possibilities you have using either technique are limited by the location you select. The more locations you can choose from, the more opportunities you have to create salable portraits.

As you look at a scene, keep a few things in mind. First, look at the color of the background. If the background is in direct sunlight, its color will determine how much light you need to add to the subject to produce the desired effect. With a dark green background in direct sun, you can get away with adding less light to the subject than with a background that is made up of lighter colors.

Many times, a lighter background is not usable in direct sunlight. Dry grass, lighter buildings, and, especially, water will be completely washed out when the harsh light of the sun is on them, with the subject placed in a shady area. Worse yet is the fact that when you diffuse this same scene, the water or other lighter-tone backgrounds begins to glow, which is a major distraction in a portrait.

When you are lining up your shot, try to keep the sun behind the subject. As direct

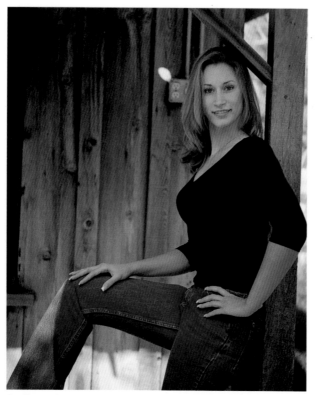 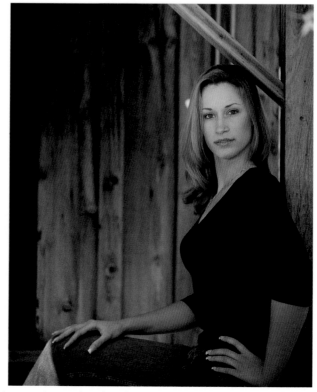

Left: In lining up a background with the subject, you can change the angle of a shot to hide problems, like the electrical plugs near the subject's head. **Right:** Here, the plugs are behind the post and are much less distracting.

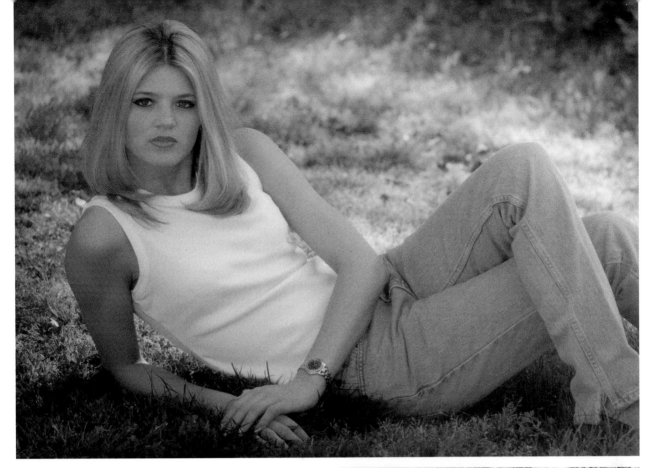

With blond hair, fair skin, or white clothing, you have to be especially careful when using direct sunlight as a backlight. We placed two black panels around the subject to keep her hair and skin from completely washing out and to create a shadow.

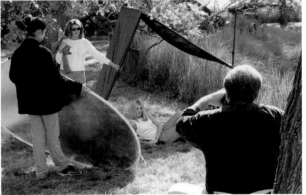

sunlight hits foliage from behind, it illuminates the leaves and brings out the vivid green color. Direct sunlight from the front, in contrast, turns leaves dark green, creating large, distracting highlights on each one. The sunlight behind the subject also acts as a separation light, separating your subject from the background by creating a strong rim light around the head and shoulders.

When using the sun as an unfiltered backlight, make sure the subject is in darker clothing. Never use a strong rim light on men with short hair because you will get highlight on the top of the ears and the ears will cast shadow down the face. Never let this direct sunlight hit fair skin because it will start to glow.

No matter how you try, no matter how thick and grown the foliage at the locations you use, you will come to a point when you see many interesting and creative backgrounds and scenes that you can't use, all because the natural light that exists won't produce a salable portrait. At this point, you must either limit yourself and the choices that you offer your clients or learn to modify the light that exists with the tips discussed in the following chapter.

CHAPTER 3
CONTROLLING NATURAL LIGHT

When working outdoors, you will eventually come to the realization that you have to take light as it is in most scenes and modify it to produce the look you want. Unfortunately, when producing outdoor portraiture, you are likely to encounter one of two scenarios: you either find a perfect scene with less than perfect light for the subject, or find nice light for the subject with the background in direct sunlight.

▶ MODIFYING LIGHT

Two separate controls over the natural light are available to outdoor photographers. "Subtractive" controls reduce the amount of light hitting an area, while "additive" controls adds light to a portion of the portrait. When I first heard about subtractive lighting it seemed much more complicated than it actually is. The use of subtractive and additive lighting is actually very easy to understand and put into practice.

To modify outdoor light, you will need equipment not discussed in the beginning of this book. To practice subtractive lighting, you must have something to keep (subtract) light from an unwanted area. This black, man-made "something" goes by many names: gobo, black gobo, black flag, black reflector, black scrim, or black panel. No matter what you call it, the accessory referred to is a flat black obstruction that can create a shadow or keep light off an area where you don't want it.

There are three theories regarding outdoor light modifiers. You have the "lightweight and/or collapsible"; the "heavier weight"; and the "cheap" way of thinking. Lightweight and collapsible panels can be purchased from Photoflex or Lightform. I use the Lightform Panels for the black or subtractive lighting and the Photoflex collapsible for the reflectors.

Both come with a variety of clamps and holders that will make your life easier. (See the resources section for details.)

Several companies manufacture heavier-weight frames for the black/white/silver/gold or translucent materials to fit over. Where I live, the wind that blows in the spring can turn any panel system into a big kite. I would rather use a flimsy piece of plastic than heavier, aluminum or steel-framed ones that could blow into and injure my client.

When most photographers start out, they tend to take the cheap route: foam core. It isn't pretty or terribly easy to work with, but it does the job. It comes ready-made for your white reflector; you can paint the other side matte black. Get a second board and paint one side glossy gold, the other glossy silver.

Of course, while some photographers are cheap, they also want to get fancy. They get PVC pipe and make a frame, then buy the materials to fit over the frame. While foam core is a cheap and easy way to create your basic panels, using PVC pipe and sewing the different materials takes up a lot of time. When it's all said and done, you might as well have invested in the Lightform panels.

I work with two 6' x 4' black Lightform panels. They clip together on one end and have a light stand attachment on the other. I use two collapsible reflectors, a 6' gold and white reflector and a 24" reflective silver. With this equipment, I can modify the light in just about any situation. Using this type of natural lighting equipment does have its limitations, however. Moving these items around takes additional time. You can work by yourself, but many times a second person is needed.

On a more positive note, the creative freedom you have when using light modifiers outweighs any of its limitations. Rather than being stuck under a tree, you can control your lighting like you would in the studio. This equipment can be used for individuals and groups of about four persons posed closely.

Subtracting Light. Subtractive lighting is used to remedy two types of lighting problems. The first is when there is no apparent shadow

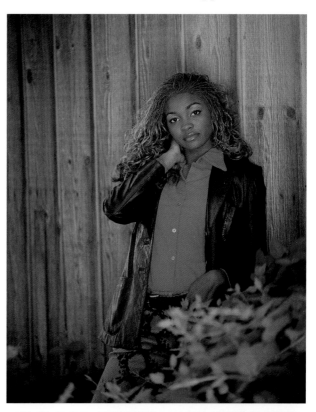

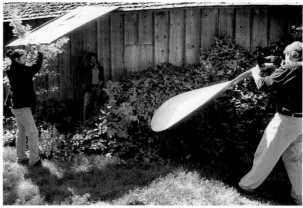

We chose to use a black panel as a gobo in this image. The photo directly above shows the setup, the one on the top shows the resulting portrait.

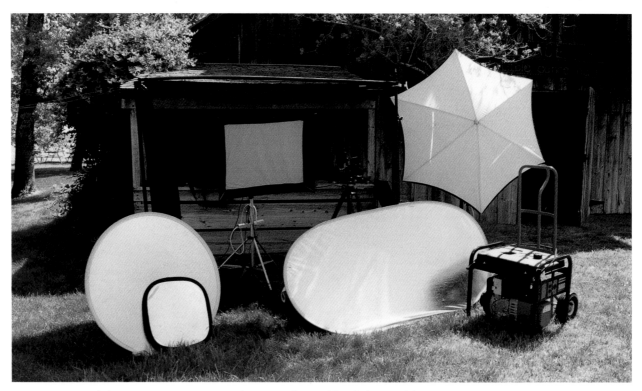

Here is some of the equipment I use in order to render midday light useable.

on the face of your subject. By placing a black panel on one side of the subject or the other, a shadow area is created. Think of the black panel as the antireflector. The closer the black panel is moved to the subject, the darker the shadow appears.

The second use for a black panel is to keep unwanted light from striking a particular area. In subtracting lighting, you can eliminate the overhead light that causes "raccoon eyes," or reduce the apparent size of your main light source. When you block light with a panel (used as a gobo), you need to keep the panel as far away from the subject as possible. If you place the black gobo too close to the subject, you will start to see light falloff in the area of the subject the panel is near. This is a definite problem when it is close to the face.

When I must place a gobo close to the face, I use a reflector as a gobo. This way you don't see light falloff on the hair or forehead. You can use the white side of a reflector if you don't want to add any light to the hair, or you can turn the gold side toward the subject to pick up a little bit of a golden highlight.

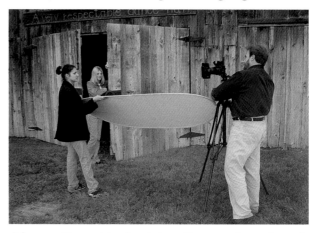

Above: The gold side of the reflector reflects the soft light of this scene for a more glamorous look. The same reflector can be used as a gobo when a panel needs to be close to the subject (a black panel placed too close to the subject not only acts as a gobo, but also subtracts light, creating an unwanted shadow area on the subject). **Facing page:** The resulting image.

Simply put, subtractive lighting takes light away from areas it shouldn't be. It is the photographer's job to determine the areas where light shouldn't be. Of course, there is no rule that should never be broken.

Adding Light. As you look out from your photographic safe haven, with the perfect lighting, from under your favorite tree, you can see a variety of beautiful scenes in front of you. In a panic, you quickly realize that the sun is beating down, frying all those beautiful backgrounds to a crisp. If you're like many photographers, you shrug your shoulders and return to your tree. It's man's way to look at nature and try to do her one better. Nature gave us birds, we made planes. Nature provided the horse, we invented the car. It seems only natural that you should try to trump nature again.

At midday, direct sunlight can ravage a background. It can take the most beautiful scene and reduce it to something akin to cream-colored background paper. As you look at areas outside your safe spot under the tree, consider the fact that you have several options in controlling the light.

The first choice is to find a shaded area for the subject, set your camera for that lighting and let the background step-up to a higher key. This works if the background is dark enough, the shaded area is bright enough, and the light on the background is soft enough. If the background is a lighter tone, the shaded area too shaded, or the background is lit by direct sunlight that is not filtered through trees or reduced in intensity in any way, you either move or modify the light that exists.

Before we discuss the various ways to add light to a scene, I need to talk about some commonly accepted wording that gives most photographers the wrong idea about adding light to a scene. Whenever you hear someone talk about working with natural light and modifying it, you hear the words "fill flash" and "reflector fill." Both of these terms have been taken from working in the studio, where they apply, and used when talking about working outdoors, where they don't apply.

Thinking about light and shadow outdoors is just about the opposite of light and shadow in the studio. In the studio, we fill the shadow. Most of the time outdoors, you have to create the shadow. Typically, the only time you resort to adding light outdoors is when you need to increase the intensity of light to balance a scene. If you are using a flash or reflector as a fill, you won't add anything to the intensity of light.

When you add light to a scene, the added light becomes your main light source, the ambient light (the light that naturally exists) becomes your fill. In this way, the intensity of light can be increased to balance a scene and you have control over the ratio between highlight and shadow.

Fill flash, or to phrase it properly, lighting the portrait with flash outdoors, is something that, in my opinion, should never be done because to do it properly requires a huge amount of work. And that's why almost no one does it properly.

Anytime you see a photographer using flash outdoors, what type of light does he have? An on-camera flash, right? We have already discussed that when you add light outdoors, this light becomes your main light source. It is used to exert some degree of control and to balance the existing light of the scene. Most of the on-camera flash units I've seen used, however, couldn't produce enough

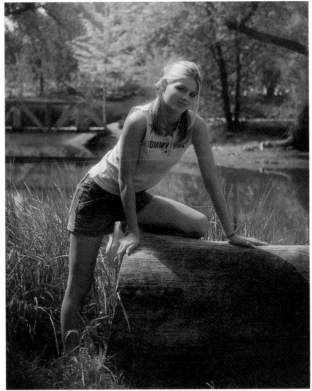

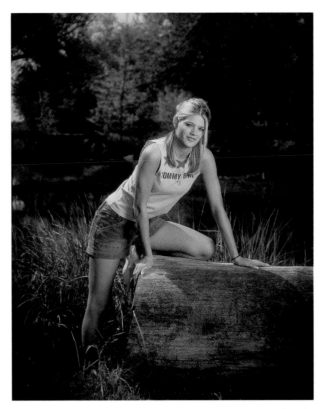

To achieve a professional quality of light outdoors, you must use the same type of lights that you use in the studio. **Left:** The setup of the shot. **Above left:** The portrait taken without the use of flash. **Above right:** The same portrait with correct flash usage.

light to act as the main light source. Not only that but, if you were in the studio, would you light a portrait with an on-camera flash unit if you wanted a professional quality image? Of course not.

The only time I use flash outdoors is when I take nightscapes, a portrait we take after sunset (which we will discuss later), or I'm forced to do a large family outdoors in the middle of the day, which doesn't happen often.

When you use flash outdoors, you need to use the same lights you use in the studio to have the same professional-looking result. This means hauling your largest studio flash, a

large light box (or other light modifier), and a generator to power them. Now you see why I said you should never use flash outdoors.

With a large light box, the light is soft, just like the light that naturally occurs outdoors. This produces a natural looking portrait, as opposed to the hard look and tiny catchlights produced by an on-camera flash.

Should you decide to endure moving all this equipment, you will be provided with a great opportunity to balance the subject with the background every time you change a scene. With a large studio flash (1500–4000 watt-seconds) there is no background that you

can't use. You don't have to deal with the squinted, watery eyes of your subject, which often happens when you use reflectors.

A flash is most usable outdoors when you are using a camera that has a leaf shutter in the lens. A leaf shutter will sync with flash at any shutter speed, while a focal plane shutter (which most 35mm and some larger format cameras use) will sync with flash at very slow shutter speeds ($1/30$ to $1/125$ second). (If your camera has a focal plane shutter, you can purchase a lens that has a leaf shutter. These lenses are available from most manufacturers—but beware!—they are expensive.)

When using a flash outdoors and a camera that has leaf shutter, you can reduce the amount of ambient light (the natural light that exists in a scene). To control ambient light, you have the shutter speed and your f-stop. To control flash, you only have your f-stop. This

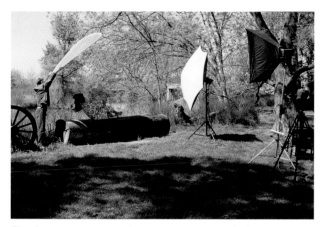

Facing page: For this image, we needed to use two lights and a reflector in order to produce a well-exposed portrait. **Above:** The setup for the portrait shows the placement of the lighting equipment.

means you can reduce the amount of light in a scene, as compared with the amount of light output from your flash, by increasing the shutter speed, which is used to darken backgrounds in direct sunlight.

Photographing nightscapes is made possible by utilizing the same control over lighting. You use a very slow shutter speed, continuing the exposure after the shutter has popped (this is called dragging the shutter). This longer exposure allows you to pick up all the colors of the skyline after sunset. In either case, the options in backgrounds and lighting effects that are possible when you haul all of the equipment around makes it almost worthwhile.

As I said before, when you use flash or reflector outdoors, this added light becomes your main light. The ambient light of the scene becomes your fill. This means that with diffusion, you can raise the exposure on the subject by two stops and still use the ambient light on the subject as the fill. When the light on the background needs to be reduced more than two stops to balance with the light of the subject, the ambient light on the subject will

not be enough to fill the shadow. This means you need to bring in another light or a reflector to fill the shadow so both the highlight and shadow will record on your negative.

To meter the ambient light on the subject, use an incident dome to see how much light you have for a fill. If the background is in complete sunlight, you can use an incident reading to measure the amount of light striking it. If you have a background that has filtered sunlight, with a range of tones, shadows, and highlights, you can remove the incident dome and just take a reflective reading from the subject position.

The reflective reading will take the entire scene and give you an average for the reading. If you take an incident reading for the background that has filtered light, you must take a reading from the brightest area of the background and the least illuminated area of the background to figure out what reading should be used.

Many technically-minded educators have complicated the metering process by talking about the way a meter reads light. This is really only important when you are using slide film, not the negative film that portrait photographers use. Slide film has a wider tonal range, but less "latitude," the amount that it can be over- or underexposed, than negative film.

A meter reading is based on 18 percent gray. Using slide film, if you metered a white wall and set your camera on the setting the meter gives you, your white wall on your slide would be 18 percent gray. You take a black wall in the same situation, exposing it for what your meter reads and guess what color your black background will record on the slide? Eighteen percent gray.

When a portrait photographer, using negative film, takes a meter reading from the light on the subject and another reading from the background, two readings are used for comparison. Since fair skin is lighter than 18 percent gray, the subject will be slightly overexposed, making the background slightly darker in comparison. For a subject that has a skin tone darker than 18 percent gray, the background will appear slightly lighter. These variations are slight and you will never see that much of a difference since the lab will compensate for any variation in density when they are printing the proofs.

When you are metering a scene and you have an incident reading of the light on the subject of $^1/_{125}$ second at f5.6 and your back-

When you don't fill the shadow, you need to feather the light off the ground in front of your subject. If you use the light in a normal position, the ground in front of your subject will be much brighter than the area around the subject.

ground meters $^1/_{125}$ second at f11, it's your lucky day. You position your main light and set it to give you a reading of f11. You put a diffusion filter on and you'll have a beautiful portrait, at least from a lighting standpoint.

Unfortunately, no one is ever that lucky. If you have a reading of $^1/_{125}$ second at f5.6 for the subject, you will probably end up with a background that has a reading of a $^1/_{250}$ second at f16 (four stops more than the fill). This means you need to raise the fill (the amount of ambient light on the subject) by two stops; to do this, your flash would need to be powered up to give you a reading of f16 and your fill would need to read f8 at $^1/_{250}$ second. To bring your fill to this light level, place a second light with an even larger soft box on it or large reflector behind the camera to raise the light to fill the shadow by two stops.

The placement of the main light is basically the same outdoors as in the studio. The angle of the light will be somewhere between 30 degrees and 45 degrees in relationship to the subject. The more contrast and shadow you want, the more you must angle the light toward 45 degrees. The less contrast and shadow you want, the closer you must position the light to the camera.

In the studio, the height or elevation of the light is easy to adjust. You have subdued room light with bright modeling lights. You raise the light until it is obviously too high and then slowly lower it until you have the lighting effect you are looking for. Outdoors, the lighting effect can't easily be seen by the model light. I usually work with the bottom of the light box about 6" below the level of the face. This is a little lower than I would use the main light in the studio, but outdoors you must light not just the subject, but also the scene in

order to achieve a natural look. If you position the light too high, there will be no catchlights in the eyes and you will have light falloff toward the bottom of the portrait.

By now, I'm sure you understand why I said that no photographer should use flash outdoors. After all, most photographers have a hard time venturing out from under their favorite tree and doing a little walking, to say nothing of carting around all this equipment. But we aren't hobbyists or "wanna be" photographers out photographing a cute girl or guy for the fun of it. We are professionals. We take our client's money, in the way of a sitting fee, in good faith that we are going to produce the best possible portrayal of that person. If you are going to do something and you are a professional, you do it right.

Some closing thoughts on the use of flash outdoors. First, use the largest light box that you have. When I say large, I'm talking about a 30" x 40", 40" x 60", 72" Starfish, or something of similar scale. Because of wind, use heavy-duty light stands with some type of weights or stake them to the ground. Using longer lenses requires that you get very long sync cords or use a radio trigger.

Many of the generators made today come on rollers with a handle. If you have one that doesn't, strap it to an inexpensive hand truck that you can buy at any home store. This way you don't have to carry it from place to place, risking getting burned. If you want to try working with flash outdoors, you can rent generators in any town. Just call any building supply store and they will tell you where the local contractors rent theirs.

Some photographers want to keep things simple. If your only purpose is to darken a burned up background, you can get by with one large soft box, without using anything to bring up the level of the fill. Again, this depends on your tastes.

The rules about the ratio of lighting are only guides. There are many situations in which I've taken portraits using just one large light source because, at that time, it was all I had. When you take a portrait that will have a higher contrast, there are a few things that can help soften the look of the contrast level. First, you must turn the face, pointing the nose more toward the main light source. If the face isn't turned enough into the main light, there will be some huge shadows produced by the nose and the shadow on the side of the face will be too large since it will record as black on the negative.

A second thing you must do is feather the light from the light box off the ground in front of the subject. When you fill the shadow, you won't notice the brightness of the ground that is in front of the subject. Since this ground area is closer to the flash than the subject, it looks washed out and very unnatural without fill. To do away with this problem, angle the light box upward, reducing the intensity of the light on the ground in front of the subject.

Without worrying about the fill, your only concern is darkening the background. The ambient light has two controls (shutter speed and f-stop) and the flash only has one (f-stop). Meter the background. You want to work with a smaller f-stop to reduce the shutter speed. If your background meters $1/250$ second at f16, you must set your flash to meter f16 and then raise the shutter speed to a $1/500$ second, and you have darkened the background by two stops. If it needs to be darkened more than this, set your flash to read f22. This makes the reading on the background a $1/60$ second

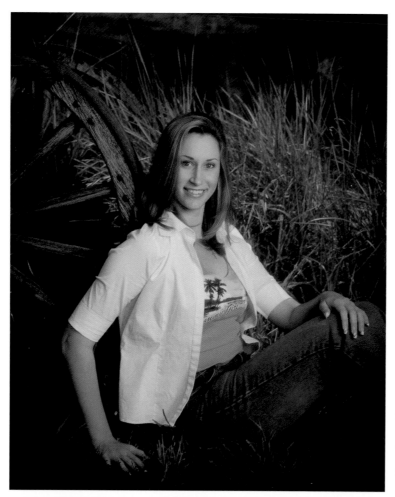

Using a two-light setup like this, you have the ability to darken almost any background and make it usable. You must take several readings from different parts of the background/scene to make sure the background doesn't appear too light or too dark in the final portrait.

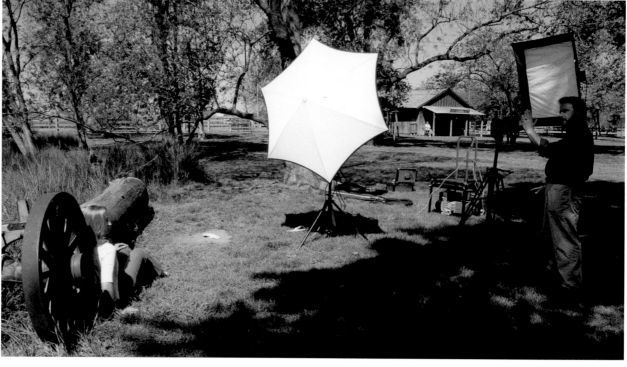

($\frac{1}{125}$ second at f16 is the same as a $\frac{1}{60}$ second at f22) and you can reduce the background by three stops. The only two limits you have are the power output of your flash and the fastest shutter speed your camera offers.

While using only one light and not filling the shadow isn't ideal, it provides more of a professional image than the fill-flash look that photographers currently have with their on-camera flash. The way you use flash outdoors is a matter of personal taste. Of course, you can decide not to use flash outdoors (which may be a wise choice), and use reflectors to achieve a similar result.

Using Reflectors to Add Light. Reflectors offer many advantages over using flash outdoors. Most reflectors are lightweight, easy to transport because they break down, don't require electricity and, best of all, the lighting effect you see is the lighting effect you get. With flash, you always work with ratios of lighting. As diverse as people in this country are, not only with differences in the shade of their skin, but also in their facial structures, you never know what the ideal lighting ratio is for each individual person. You basically have to wait until you see the proofs to see if the ratio of lighting you chose was correct.

The only downside to reflectors is that the light can be brutal, especially to someone who has light-sensitive eyes. Flash allows you to use a subdued modeling light to gauge proper placement. Using a reflector can be challenging, as it can create a variety of client reactions, from squinting to the entire face wrinkling up.

There are many ways to deal with the problems caused by the light intensity of the reflector. Some subjects can handle direct sunlight being reflected into their eyes, at least for the brief time it takes to do the portrait. When working with subjects that are light sensitive, simply ask them to close their eyes and tell them what expression you want them to have when their eyes are open. Then, with their eyes closed, count to three, guiding them as you say each number. "One . . . ok, start smiling . . . two . . . and three." It may take a few shots to get the pattern down, but for the brief second it takes to snap the portrait, your client's expression will be comfortable.

The choice of subtractive and additive reflectors will naturally be determined by the scene. Most of the time, I find that the light that nature has given me, even in a perfect setting, can be improved upon. As I look into the eyes of the subject, most of the time the catchlights are not quite intense enough or the color of the eye isn't visible. So we almost always use some type of light modifier.

This light under your favorite tree is as close as it gets to being ideal. Branches and foliage block the light coming from directly overhead and lower the angle of the light to beautifully light the face. You have obstructions in front of the subject that reduce the size of the open sky (or other main light source) in relationship to the subject, creating proper lighting on the face and the right size and placement of the catchlights in the eyes. You also have another obstruction that creates a nice shadow. Finally, you have a beautiful background that is illuminated with the same intensity of light that is illuminating your subject. You know that this scene will be rendered the same as it appears to your eyes.

In a situation like this, you have every control over your lighting that you would in the studio. The only thing missing in this perfect

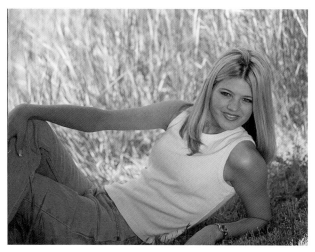

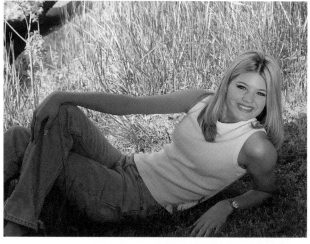

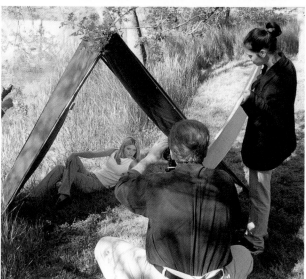

Above: The white side of a reflector provides the softest light. You'll get the most usage from a white reflector when you are in direct sun and your subject is in shade. **Top right:** The gold side of the reflector reflects a greater volume or light than the white side, and is more useful than the white side when the subject is at a distance. Also, the light it reflects is attains a warm color that I feel looks more natural in outdoor portraiture. **Right:** The setup for the images above.

spot is a light coming from underneath the subject to add more of a glamorous look. A light or, in this case, a reflector coming from a lower angle, smooths the complexion and brings out more of the eye color.

The type of reflector we use for this varies, depending on the light that will be used with it. If the camera is positioned in a heavily shaded area, the gold side of the reflector should be used since the light is so soft. In shade, the light is so soft you won't see much of a difference using the white side of the reflector. When the light is really soft, we use the highly reflective silver, which reflects a great deal of light, even with its small 24" size.

Considering the following three factors will help you to select the correct reflector for the scene:

1. The amount of light you have to reflect
2. How much light you need reflected to balance the scene
3. What you want the characteristic of the light to be

The white side of the reflector provides the softest light. I always start off with white and, if it is bright enough, I use it. I use the white side most often when I am positioned in direct sunlight and the subject is in shade. I put the

loop of the 6' reflector over one of the knobs of the tripod, the other side rests on the ground. In this situation, the white reflector is perfect—it is usually just enough light.

Unfortunately, white doesn't reflect enough light to use in the shade or when working at a great distance. The greater the distance the light source or the reflector is placed away from the subject, the greater distance the light must travel and the less its intensity. The greater the distance, the smaller the light source becomes in relationship to the subject.

Inside the studio, I use a 42" Starfish light box for my head and shoulder poses and a 72" Starfish for my full lengths. Because the 72" Starfish has to be positioned farther from the subject for full-length poses, it produces the same quality of light (how soft the light is, size of the catchlights in the eyes, and contrast), as the 42" Starfish does working with it closer to the subject.

To put this simply, the greater the distance between your light source and your subject, the larger your light source must be. This is why we use a 6' reflector instead of a 48" one. Working with full-length poses, or with longer lenses, you most often use a reflector at or near camera position. That's a long way for your reflected light to travel.

The gold and silver fabric reflect a greater volume of light than the white. We use these fabrics when we are working at a greater distance. The color choice is one of taste. Silver reflects the same color of light as the source. The gold material naturally changes the light to a golden color, which looks warmer and, I think, more natural in outdoor portraiture.

We used to use only the gold and white reflector, which worked fine, but I was sent the small 24" silver reflector as a free gift for purchasing another product. This little silver reflector has really come in handy. It's great for head and shoulder poses when you are working in shaded areas, when the reflector will be placed close to the subject. The silver reflects a huge amount of light and is perfect for use in shaded areas.

Reflected light shares the same properties as the light coming from an umbrella, or umbrella type soft box in the studio. It is controllable in that you can determine where the light from the reflectors strike, as well as where it doesn't. It even allows you to increase or decrease the intensity of light by the angle at which you position it.

As you use reflectors, you will find that you rarely use raw sunlight being directly reflected into the face of the subject, unless you are using the reflector at quite a distance.

Feathering the light from a reflector is just like feathering the light from a light box. In this photo, you can see that the direct beam of sunlight is over the subject's head and the softer light is illuminating her face.

All of us have been told the easiest way to get the softest light possible is to use the edge of the light. Some photographers use the term "feather the light," which is just using the light rays coming out of the side of the light box to reduce its intensity and soften the effect. The same is true for a reflector. The softest light is produced when the edge of the light is used.

In the studio, it is very easy to see the effect of feathering, or using the edge of a light source. You have subdued lighting and a strong modeling light that allows you to see the variations in softness and contrast. Using reflectors, the differences are more subtle.

Learning to feather your reflector is just a matter of first finding the light. When you begin to work with reflectors, you will know what I mean. Often, you have to keep moving and changing the angle of the reflector to see where the beam of reflected light is striking so you can determine how to move it into position. Once you have control of the beam of light, you angle it above the head of the subject, and slowly start to lower it until you have the intensity and quality of light you want.

Don't angle the light beam at ground level and work up. If you do this, you will stop when the light effect on the face is what you want, but unfortunately, the waistline area (if standing) or the area in front of a subject who is seated on the ground will have the direct beam of light hitting it, making it much lighter than the face. You will be drawing the eye of the viewer away from the face and straight to the stomach or ground in front of the person, depending on the pose.

With the direct beam of reflected light 5'–6' above the head of the subject, you will notice the face of the subject starting to brighten up, and more distinct catchlights appearing in the eyes. As you lower the beam, you will notice more and more light illuminating the face because you are using just the edge of the light rays, feathering off the harsher light above the subject.

To keep the reflector as well as the light in place, you either have to use a stand, which all companies make for their reflectors, or you have another person hold the reflector. Working with seniors, who always bring friends and/or parents with them, I typically use a person to hold the reflector in place. This saves time and the effort of carrying around the stands.

Adding light with a reflector is basically the same as using a flash. You can increase the light up to two stops more than the ambient light without losing detail in the shadows. Once you go over two stops more light than the ambient, your subject will scream out in pain, and you will, of course, need a second reflector to bring up the intensity of light that will be filling the shadow.

Three Types of Scenes You'll Encounter. Naturally, there are many more than three types of scenes that you will encounter. Each scene is as unique from another as the locations themselves. I have broken down the types of scenes into three categories to make them easier to understand, and make the inherent problems easier to deal with.

Once in a while you will encounter a scene that is perfect in every way: perfect light, per-

Facing page: When there are no obstructions to help you block light from your subject, you must create them yourself. The image above was shot using black panels overhead and to the side of the subject to cut the direct sun. Reflectors were then used to direct light back where it was desired. Don't let the lack of a perfect location deter you from making a great photo.

fect shadow, sunlight hitting the ground in front of the subject just close enough to add a touch of light coming from a lower angle and a background that is not only beautiful, but lit by the same light that is illuminating the subject. To photograph a subject in this situation, you have nothing to worry about, except the pose and the expression. You will come across this situation every so often, usually under your favorite tree. It's so easy to work in a situation like this, it's no wonder that photographers have such a hard time leaving it. Other opportunities for a perfect situation are found in covered walkways, patios, and archways.

The second type of scene lacks an element (or elements) of the perfect scene. It may have a main light source that is too large, no shadow, a background that is too bright, or no overhead obstruction. Although these scenes aren't perfect, most of the elements needed for control are present and provided to you by nature.

Problems encountered in these situations can generally be corrected with a single reflector or gobo. However, you must first be able to identify the problems. Look into the eyes of the subject. What do they tell you? Study the face. Is one side darker than the other, indicating shadow? Meter the background. Is the background going to render a tone that works for the image you want to create? Fix the weak aspects of the scene until each component of the portrait is correct.

The third type of scene so appeals to your creative side that it overrules your logical side, which tells you that everything about this scene is wrong. In any location, there is always one intriguing element that just happens to exist in the middle of nothing. In this situation, you have no obstructions available to help you control light. If you're like me, it's not a problem, just a challenge.

In a situation like this, you are an artist with a blank canvas. You will place areas of light and shadow only where you want them. Of course, you must place an obstruction both overhead and to one side of the subject to block the direct overhead light and create shadow. With these two obstructions in place, you have lowered the light intensity on the subject even more than it was. You must add light to the subject to balance the amount of light on the subject with that of the background. With the darker tone that exists in the background, we don't need to increase the added light more than two stops, so only one reflector is used. Since we are using the reflector at a distance, direct sunlight is being reflected into the face.

There is a point when a scene has too many flaws to produce a professional quality image. Part of being a professional photographer is knowing the limitations of your equipment and experience. Typically, the biggest problem that you will encounter in midday is a scene with a background that is burned up by direct sunlight.

Imagine that your subject is in shade, which meters around $\frac{1}{125}$ second at f5.6, your background is in direct sun, which meters at a $\frac{1}{250}$ second at f22, and you only have reflectors to work with. In this situation, you either let the background burn up, blind the subject by reflecting direct sunlight into his or her face at a very close distance or, if you're smart, you look for another scene. Never let your creative side become so attached to a scene or scene element that you waste time and money trying to manipulate a scene you know won't work.

Most of what you need to know about the light in any given situation can be found by looking into the eyes of your subject. As we have been told many times before, the eyes are the windows to the soul. In addition to being the windows to the soul, the eyes become the indicator of good light.

▶ CATCHLIGHTS

It is important to remember that if the eyes aren't properly lit, you will not have a salable portrait—no matter how perfect the other characteristics of the portrait seem to be. By looking into the eyes of any portrait, you can tell the type, height, and angle of each light that was used to light the portrait. You can even gauge the photographer's level of experience by studying the areas where catchlights appear. You can tell if there was a shadowing on the side of the subject's face to create the illusion of a third dimension, just by looking at whether the catchlights on one side of the eye or are directly in the center of the eye.

To determine where these bright white highlights should appear, mentally divide the pupil and iris into quarters. The catchlight should appear in the upper quarter of the iris. If they occur in the pupil area, the light is coming from too low and/or too close to the camera position to be usable. Never let the catchlights appear in the whites of the eye, which usually indicates the light is coming

QUICK TIP

If you have a subject without an apparent shadow area, with broad catchlights going from one side of her eye to the other, and whose face looks good in that light, you would be a fool to make any changes.

from too far to the side of the subject and not high enough.

Many outdoor photographers make the same lighting mistakes over and over—all because they never take the time to look into their subjects' eyes. The following subsections will explain how incorrect catchlights can reveal lighting problems.

No Distinct Catchlights. This is the biggest mistake I see. This happens not only in outdoor portraits, but in the studio portraits taken by both young and experienced photographers as well. Without a distinct catchlight in each eye, the eyes are lifeless. When a client's eyes look lifeless, they don't buy their portraits. When you can't see catchlights in the eyes, you have no main light source, or one that is so large and soft that it produces an even illumination of the entire eye. In either case, look for more direction in your light source. A lack of catchlight happens most often when you face the subject into a huge expanse of open sky. Look for some obstruction to block more of the open sky to get more direction to the light.

Multiple Catchlights. Multiple catchlights are produced by having more than one source of light. This is especially a problem when you are working at midday, since intense light is bouncing all around and is reflecting off of everything. In this situation, one of the catchlights is more intense than the rest. You can eliminate the excessive catchlights by turning the subject or placing a gobo to block the light from these extra light sources. In most of my portraits, you will see two catchlights in the eyes. One in the normal position in the upper eye and one in the lower eye. I personally like a little more glamorous look to my lighting, so inside the studio or outdoors, I always have a

No distinct catchlight.

Multiple catchlights.

The catchlights are at too low an angle.

Catchlights at too high an angle.

Catchlights are small and intense.

Catchlights are in the proper position.

reflector or natural setting that provides a little light from underneath the subject.

Catchlights That Are Too Low. As I mentioned earlier, the catchlight should be found in the upper quarter of the iris. If the catchlight is lower than this, you usually have an object or grassy area in front of the subject that is in direct sunlight and is overpowering the light from the open sky. While I place a light/reflector under the subject, the light produced is less intense and therefore creates a less noticeable catchlight than one produced by the main light source.

Catchlights That Are Too High. Sometimes you can see a catchlight in the eye, but it appears directly under the eyelid and usually lacks intensity. This is usually accompanied by "raccoon eyes," or slight circular shadows under the eyes. When your catchlights are too high, your main light source is coming in from too high an angle. This usually happens when there is little or nothing over the subject to block the light coming from directly overhead.

Small, Intense Catchlights. This means that you, like many photographers, have attempted to use a flash outdoors and achieved that completely unprofessional on-camera flash look, or you have a naturally occurring, very small, intense main light source. The lighting effect on the face will be similar to that of a spotlight or small battery-operated flash unit, which means the lights will be very contrasty and hard. Generally, the larger the catchlights, the softer the light. Soft light is more forgiving, and does not bring out imperfections in the skin and face.

QUICK TIP

Many traditional photographers think it is taboo to see a second catchlight in the eye coming from a lower angle. I like this look. You can't pick up a fashion/glamour magazine today without seeing the majority of the photographs with a second or third catchlight in each eye. Many photographs and ads on TV are shot with a modified ring light, which is just a very large version of the ring light used in macro photography.

Each time we have changed labs, I have had to put a big note on any print the artist will see, instructing him or her to leave the second catchlight. We were with one lab for a short period of time and I got tired of telling the artist over and over again to leave this catchlight. So I just started sending them back to the lab to be remade properly. You are the creator of your work and you determine what type of lighting and controls to use based on what your clients ask for.

CHAPTER 4
SELECTING THE PERFECT SCENE

As you walk through an outdoor location, you will come across countless scenes that can be used as a background for a portrait. With such variety, it's easy to become overwhelmed and basically not see the forest because of all the trees. When searching for a useable scene, a photographer generally considers the following: Where is the light coming from? Is it producing the effect I want? Is the light on the background going to work with the amount of light on the subject? We have discussed these concerns in the previous chapters. One thing that some photographers seem to overlook is the feel of a scene. A scene, whether it is created in the studio, or located outdoors, stimulates the viewer in one way or another. Components of the scene bring out certain emotions and feelings when the portrait is viewed. In knowing what effects certain background elements have on a portrait, you will have the ultimate creative control over your portraits.

If you have ever studied art theory, you're in luck. If you haven't (which most photographers should, but don't), you will need to learn not only what a scene will look like in the final portrait, you must also understand how a scene will feel in the final portrait. It would take many books to completely explain art theory (you should read a few of these when you finish this book). Although the subject is complex, the following sections will function as an introduction to the topic.

▶ BASIC ELEMENTS OF A SCENE

While several elements create emotion in a typical scene, we will discuss only three in this book. In any given background/foreground, the three basic elements that create a particular feel are color, lines, and textures. In outdoor portraiture, lines and textures have

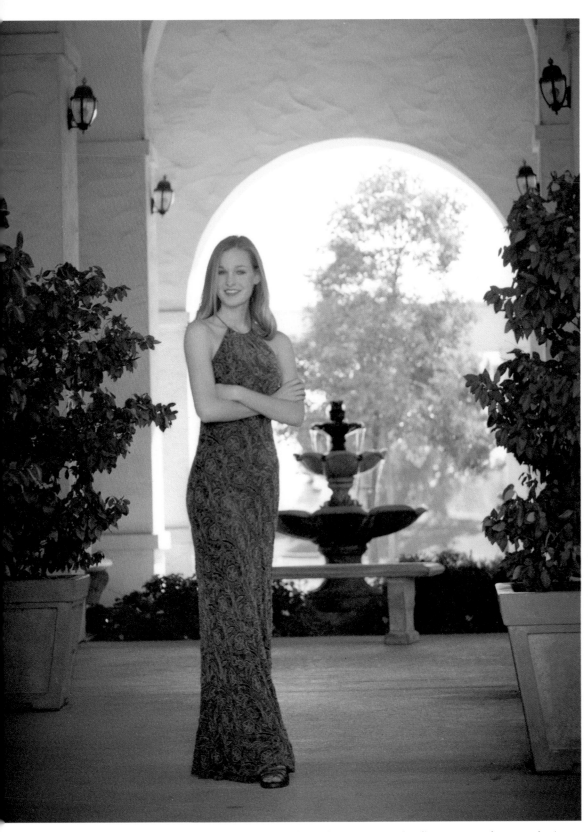

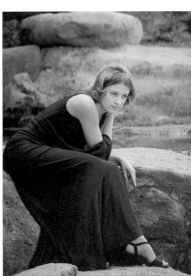

Whether it's foliage, a creek, or an archway, lines that are curved reflect a more feminine feeling.

Above and facing page: *Many backgrounds are comprised of both feminine and masculine lines. In this situation, the basic look of the portrait will depend on your client, the clothing, and the pose you select.*

the greatest impact on the feeling conveyed by an image.

Colors. Colors in outdoor backgrounds are more limited than the selection available in the studio. In a garden scene, you have shades of green and brown—green being the foliage and grass, while the browns are made up of the the exposed wood and dirt. We like to think that water adds color to a background, but in the average garden, the water has a green or brown tone that is similar to other elements. These earth tones help to create the warm, natural feel that most portraits taken outdoors have. Even the fences, archways, and most of the buildings that we sometimes use as an alternative to a garden scene are composed of these earth tones. For outdoor photographers, then, color offers the least amount of control over the feeling that a portrait will have.

The only other colors available occur seasonally, when spring flowers add vibrant colors to the scene. Many of these colors are so vibrant that the flowers become the focal point of the portrait. When using these spring flowers, the colors of flowers do translate into feelings. The yellows, softer oranges, and pinks (the pastels) have a more informal feeling. More casual styles of clothing and relaxed poses would be selected for these colors. The darker tones of purple, red, and maroon have a richer feeling, so nicer clothing should be worn by the client.

Lines. The second visual communicator is lines. Lines are everywhere and in every background. To simplify a complex topic, lines that are curved have a softer, feminine feeling. We have all heard of the classic S-curve in posing the female subject. Straight lines have a stronger feeling and are labeled masculine.

This doesn't mean that you can't pose a woman in a background with straight lines or a man in a background that has curved lines. By putting a woman in a setting that would be considered masculine, the portrait will reveal her stronger side. Placing a man in a setting that would be considered feminine will bring out a softer feeling in a portrait.

The client's personality and motivation for taking the portrait will determine what type of background is appropriate. If you are taking a portrait of an executive (man or woman), they will want a portrait that will portray their strength. If you are taking a portrait of an artist (man or woman), they will want a portrait that will portray their softer, more creative nature.

Most backgrounds have both masculine and feminine qualities. What you need to do is look at the strongest elements in the composition and determine what feeling they portray. If you are using foliage in the background, ask

yourself if the lines visible "through the camera" (the lines will change with limited depth of field of the camera) are straight or curved. If there is a pathway in the background, is it straight or curved? When using a pond or lake, do the banks form a straight line or a curved one? When using a covered walkway, are the columns square (masculine) or rounded (feminine)? In this covered walkway, is there an arch at the roofline (feminine) or is it squared off (masculine)? By observing the predominate lines of the background, you can tailor the feelings the background produces to fit the emotional response your client wants the viewer to have.

Textures. Texture is the last of the three visual communicators that we will discuss. In any portrait, the textures of the background must be viewed through the camera because the camera changes the background textures so much. Naturally, the softer the textures in the background, the more feminine the look of the background. The harder and bolder the background textures, the more masculine the feeling the background will produce.

Background texture is the only one of the three visual communicators you have complete control over. By controlling the depth of field and the distance between the subject and the background, you can soften or increase the texture of any background. If you have heavy textures in a scene (tree bark, a brick wall, foliage with bladed leaves), and you want to pose a woman with a very feminine dress for a portrait that is to be given to her husband, you would simply stop down the lens and pull her farther and farther away from the heavy texture to increase the softness.

Sadly, these visual communicators are missing in 90 percent of portraits taken today.

To soften the lines of this photo, a diffusion filter was used. Further softening was then done by controlling the depth of field and the subject's distance from the background.

There are certain photographers and artists whose work has a sense of style that sets it apart from more "common" work. The difference is that these artists have taught themselves to look beyond the technical considerations that photography requires. They have also trained themselves to see as an artist sees.

▶ THE IMPACT OF FOREGROUND

In a scene, you not only have the ability to evoke a certain emotional response from the viewer of a given portrait, but you have the greatest opportunity to create a three-dimensional feeling on two-dimensional photograph-ic paper. When most photographers look at a scene, they think in terms of the light, subject, and then the background. Light and the background can create some feeling of depth in a portrait, but it is limited without one important element . . . the foreground.

When taking portraits, many photographers don't look for a foreground, or area in front of the subject. Although this is more common in outdoor portraits, you hardly ever see foreground used in studio portraits. When a portrait has an element in the foreground, a subject in critical focus, and a background that goes farther and farther out of focus, that portrait appears to be three-dimensional.

Creating a foreground is easy. Rather than placing your subject in a clearing, with the foliage behind them acting as a background, move your client into the middle of the foliage. In doing so, you will create both foreground and background elements. When you are working with structures like columns, archways, fences, or walls, place the subject near the middle of the structure, instead of the edge. This way, part of the structure becomes the foreground, with the rest of the structure as the background.

I like to use foreground elements that I can shoot through that basically frame the portrait. Greenery can often be used as a foreground vignette to soften the edges of the portrait. This provides two important benefits: it creates depth in the image and adds impact to the portrait.

A foreground can also be used to hide or disguise a number of problem areas in the portrait. Whether a client is wearing white socks

Facing Page: Most photographers place their subjects at the edge of the background, without anything in the foreground. By carefully placing the subject in the scene, you can use the foreground to create depth and add a finished look to your portraits.

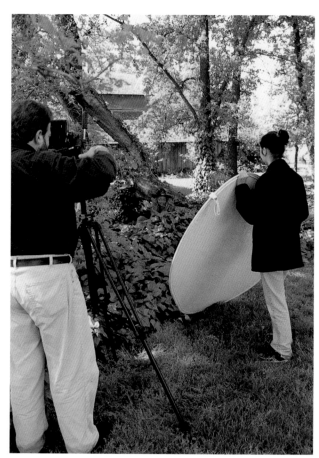

Sitting a subject in thick foliage, whether it is ivy or grass, can hide many of the problems that clients worry about the most. Heavy hips and thighs, a less-than-flat stomach, the wrong color socks and old shoes can all be hidden while taking a pose that still shows most of the subject's body.

with dark pants, wants to go barefoot (although they have bright blue toenail polish on), or is wearing a dress that is about an inch shorter than some would consider indecent, tall grass or some strategically placed branches can help to salvage a portrait.

While these problems are all obvious and easy to spot, many of your clients' problems are less noticeable. If you are a woman, or married to one, you will have a much easier time understanding this concept than a single man will: In this country, there is, no matter how much we think we have evolved, a double standard when it comes to appearance. The majority of woman feel that their standard of beauty is set by the models who appear in

fashion magazines and on television. Guys, on the other hand, feel they're doing pretty good by looking better than the guy next door. This leads to women being much more critical of themselves in a portrait than men.

After working with young ladies for the last fourteen years, being married, and raising a daughter, I can honestly say that most women subscribe to this school of thought when it comes to their appearance. Some of you are thinking, "What does this have to do with me? I take pictures, I'm not a plastic surgeon!" The truth is, this sentiment has a lot to do with you, because if clients are unhappy with the way they appear in their portraits, they won't buy them.

The number one concern of both men and woman is their weight. No one is ever thin enough. While a man shows signs of weight gain in his stomach and double chin, a woman tends to carry her weight in her hips, bottom, and arms. Most guys have to gain twenty to forty pounds before they even notice the weight gain. When ladies gain just a few pounds they start to worry.

For the benefit of male photographers who may be unsure exactly which areas a woman typically worries about, I have compiled a list: size of the hips and thighs, size of the upper arms, hair showing on the forearms, hands appearing large, waist not appearing thin enough, and calves and ankles appearing too thick. In other words, they worry about pretty much everything from the hairline down.

The best way to deal with whatever problem area you encounter is to utilize foreground elements to hide or soften them. Setting a young lady with heavy thighs or legs in tall grass can reduce the appearance of size by obscuring part of the outline of the problem area. In a standing pose, a strategically placed branch can hide or soften everything from a tummy bulge to large arms.

Whether you use the foreground to add the feeling of depth to a portrait, or soften reality to spare your client's ego (as well as make a sale), ensure that you include a foreground in every portrait. Using a foreground element in a portrait can make the difference between a nice portrait and an exceptional one. So after you find your light and find your background, look for an element in the foreground.

▶ ART IS DETERMINED BY THE EYE OF THE BUYER
The title of this chapter is a little deceiving for there are no "perfect" scenes, just scenes that

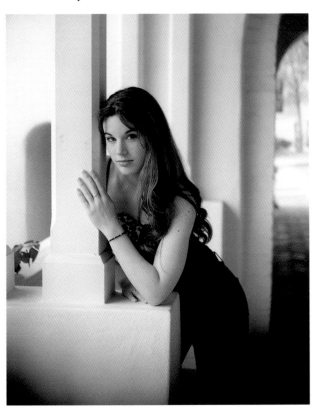 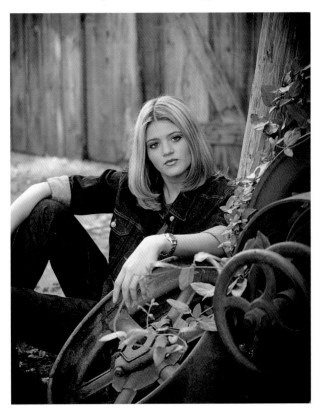

Foreground elements can greatly increase the feeling of depth in your portraits. Use them where appropriate.

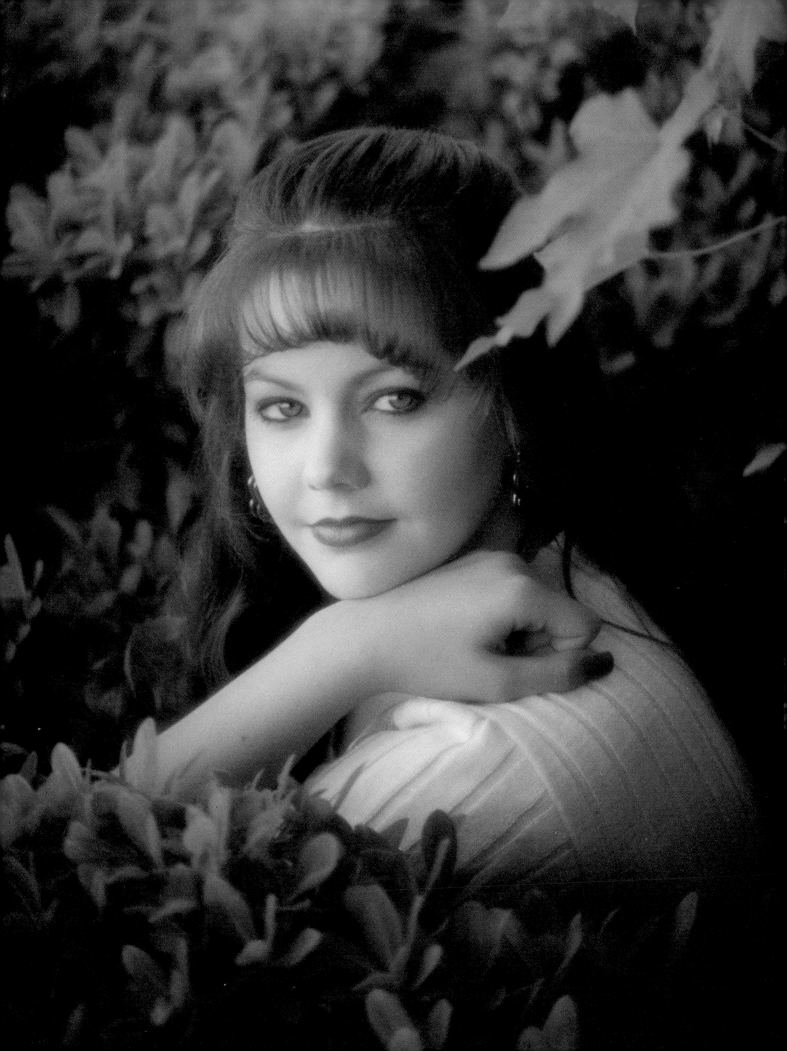

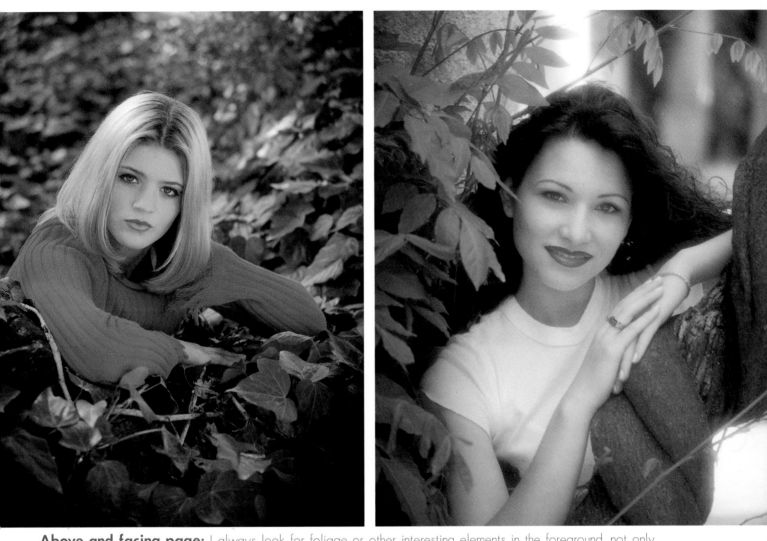

Above and facing page: I always look for foliage or other interesting elements in the foreground, not only because they create depth in an image, but act as a natural vignette as well.

The ability to correct problems, such as the wrong color pants, white socks with dark pants, and/or a heavy hips/legs, a not-so-flat tummy, or large arms can mean the difference between a profitable session and a lost sale. Foreground elements can hide many of these problem areas. Note the differences between the two photos shown here.

look better than others. In every scene I look at I wish I could move a tree, change the angle the river flows, or the direction of the sun. If we could do these things, any scene could be perfect. Because we can't, we must settle for near perfection.

Many times, it is not the scene that makes our portrait less than perfect, it's the request of a client. You can be at a scenic location, with acres of usable backgrounds flowing farther and farther from your eye and your client says they want nothing but head and shoulder poses. Every part of you wants to create beautiful scenic portraits, using all that nature has

provided you, but you must not forget the golden rule: art is determined by the eye of the buyer.

Years ago, when I first started my studio, I worked with all types of clients. Beside seniors, my second favorite type of client was families. I studied all the unique ways to pose family groups, and strove to select locations that would reveal something about my clients. I became known in my area for the family portraits I had created.

Upon hearing numerous glowing reviews of my family portraits, I became quite full of myself. I started to think I knew more about

what type of portraits my clients should have than they did. On one occasion, I was scheduled to photograph a family that I knew was going to be a problem. They didn't want to come in for a consultation, they didn't want me to come to their home to select where the portrait was going to be taken. They told me that they knew what they were wearing and had selected the area where the portrait would be taken.

I was looking at their home, which was really beautiful, but they wanted to use a white wall as the background. After talking with them, I knew their minds were set, so we continued. As I started posing each person,

the grandfather stopped me, went to the mantle and got an old portrait. There were five men standing in the back row, with their wives sitting in front of them on a bench, against a white wall. The grandfather said, "This is what I want!"

I explained that we could improve on this portrait by selecting a better location and much more flattering poses. He said no. Being very discouraged, I created the portraits the way he wanted them, thinking to myself that they were going to get a 5" x 7", like the one on the mantle, and that would be it. When the proofs came back from the lab, I had created the exact same portrait, but with ten new

The foreground is a wonderful tool for portrait photographers. Compare these two photos.

faces. When they picked them up, I expected I would take my $30 order and be done with it. They returned two days later with an order that totaled over $3000. Each couple in the portrait ordered a smaller wall portrait and smaller portraits for all their children.

Don't ever let your feeling about the way a session should be taken outweigh the wishes of a client. If you want to be that much of an artist, take up painting. As artists, we face the ultimate challenge—creating a portrait that has value, not only to ourselves, but to our clients as well.

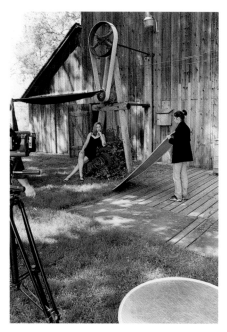

Horizontal or vertical? This depends on whether the subject is posed "tall" (standing/sitting up) or wider (lying down). It also depends on how much of your subject you want to show. Many times a pose will be perfect for a vertical full length, but a client won't have the correct shoes, doesn't like the appearance of his or her legs, or wants a larger facial size (you know how moms are). In this case you have the subject turn his or her legs more to the side to fill the bottom of the frame and shoot the portrait as a horizontal.

Often, greenery can be used as a vignette to frame the subject. This simple yet effective use of foliage eliminates lines that lead out of the frame and focuses your attention on the subject.

Always be on the lookout for posing aids. The back of a park bench, a horizontal branch coming off a tree, or a log laying on the ground are all excellent bases to pose your subject on for more creative head and shoulder poses.

CHAPTER 5
URBAN SCENES, ARCHITECTURE AND NIGHTSCAPES

When most photographers think of outdoor portraits, their thoughts turn to the garden around their studio or their favorite spot at the park. While many beautiful portraits have been created in these spots, it seems that with all the beauty that surrounds us in this world, returning to the same spots and thinking that outdoor backgrounds must incorporate greenery can be rather limiting.

Consider this simple fact: To a client that is not educated in the art of photography, your foliage-filled backgrounds probably look pretty much like the backgrounds used by the studio down the street. As we all know, when a product or service is no different from that of a competitor, it all comes down to price. How much are you willing to give away to get a client into your studio?

A wise person once said that there are no new ideas, only unique twists and changes to old ideas that make them seem original. In this chapter, we will discuss three twists to old ideas, only one of which can I take credit.

▶ URBAN PORTRAITS

Urban portraits are taken using street scenes, overpasses, railroad tracks, and city streets. These scenes are a great alternative for a client who doesn't want a typical outdoor portrait. These portraits became popular about ten years ago in the senior market and, while this twist was not my idea, I have taken urban portraits into new and exciting directions.

The same principals that apply in traditional scenes—lighting, background selection, and the feeling created by color, lines, and textures—apply to urban portraits as well. The basic differences between the two portraits lie in clothing selection and the client safety issues that you may encounter in some of the locations that you chose.

Urban portraits use street scenes. Railroad tracks, underpasses, warehouses, etc. make these portraits unique. This style is perfect for the client who wants their portrait taken outdoors, but is looking for something different.

Since creating a street feel is what these portraits are all about, clothing should be casual, but harder looking (jeans and boots, T-shirts and leather jackets/vests, flannel/denim shirts, etc.). You don't want your client to look like a biker, but a young lady in a prom dress standing on railroad tracks wouldn't visually make sense.

Client Safety. The second concern of these portraits is safety. Some people use no common sense when it comes to their own or their client's safety. If you take a client into a situation she assumes is safe (without a release of liability) and she is attacked or injured, you could very well spend a good portion of the rest of your life working to pay off a lawsuit.

I find that it is a good policy to look at each new idea first for its profitability and then for its liability. If you put your client's safety at risk, you are risking not only your future, but quite possibly your children's future. That being said, you can also worry too much about safety. There are many people that worry about going even slightly outside of their own neighborhood. Use common sense—be creative—and be safe.

We typically require our clients (or a parent/guardian, if they are under eighteen) to sign a release of liability when shooting beyond studio property. The release simply states that in the world we live in, random acts of violence can occur anywhere and at any time, and that although the locations we go to are considered safe, the studio cannot be held responsible for client safety, or held liable for any harm that may come to our clients or any-

Urban scenes are interesting settings for those clients not looking for a typical outdoor portrait.

one who may accompany them to their outdoor session.

I always work to make sure that my clients are as safe as humanly possible. On that note, *Rangefinder* magazine published an article I wrote that was illustrated with a portrait of a young girl sitting on railroad tracks (see a similar portrait on page 55 of this book). I received a long e-mail about the hazards involved and negative message that I was sending to young people (who might play on the tracks) and to photographers (who might use tracks and get hit by a train). The author of this e-mail worked as a part-time photographer and also worked for the railroad. For the record, the portraits I take on railroad tracks are created on a siding rail that runs behind my studio. These tracks are used about two

days a year, mostly for the storage of boxcars. You could only get hurt on these tracks if you took a nap there on one of those days and you are a sound sleeper. Obviously, common sense should always dictate your selection of locations for portrait sessions.

Black & White. While black & white or sepia tone black & white is always a popular choice for street photography, the cost can be prohibitive. Processing costs are higher and most printers are only set up for custom printing. Talk about cutting into profits—can you imagine ordering forty-eight custom wallets?

As a businessperson, as well as a creative person, I knew that using black & white film to produce black & white images was financially impossible when working with seniors. Years ago we started using Ilford's XP2, which is a

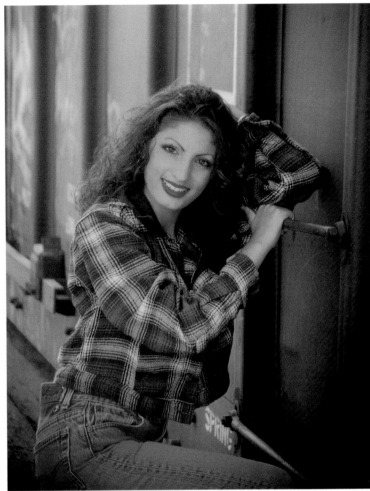

Above: In these urban shots, a "street feel" dictates that the clothing should be casual, but harder looking. **Facing page:** When shooting on location, use common sense and remember safety. Safety should always be your number one concern.

C-41 process black & white film. The labs hated it because it was very difficult to color balance and get anywhere close to black & white. Now we use Kodak's T-Max 400-CN. This film is also C-41 process, but the labs tell me it is much easier and much less costly to print and achieve true black & white tones.

▶ ARCHITECTURAL PORTRAITS

Architectural portraits have been done for years, but primarily in wedding portraiture in which the architectural components were included simply to show the location where the couple was married. Architecture was also

sometimes pictured in fashion ads, or when a family portrait was taken at the clients' home. Although Mother Nature's creations are beautiful, man's contribution to the landscape—all the interesting lines and textures created by the arches, columns, fountains, windows, carvings, and surfaces of all the buildings that surround us—is no less astounding. And for many of us living in larger cities, beautiful buildings are easier to find than beautiful nature landscapes.

As you think of using architecture as the setting for portraits, you will probably start to think of older buildings with gothic columns,

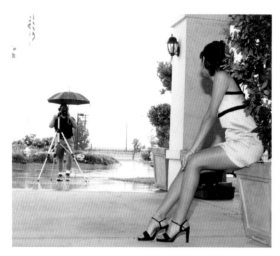

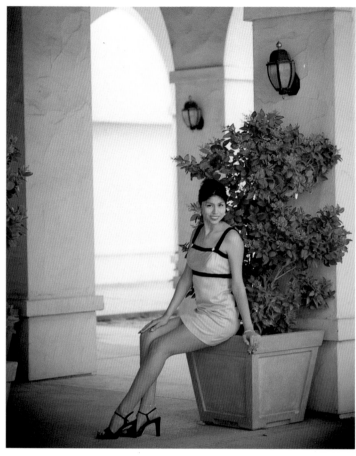

Architecture can provide your clients with other options for outdoor locations. Whether you choose to employ classical or contemporary structures in your images, these portraits will help set your studio apart from the other studios in your area. Note that this portrait was taken on a "cloudy bright" day. The setup is shown above, with the resulting portrait to the right.

cathedral ceilings, and large French-style windows. While this classic type of architecture does provide a beautiful setting and the feeling is elegant and upscale, it may not work well for the image you are creating. If you are photographing a young man or woman in casual clothing who wants a more informal portrait, for instance, you must look for a style of architecture that reflects the feeling that you and your clients want. Many times a single location offers several styles of architecture that will translate into many different feelings. We have one public park that features everything from gothic columns, to a castle, to a log cabin, to a story land complete with little buildings from nursery rhymes.

While the area you live in may not have a park like this one, interesting architecture is available in any town. Typically, the oldest areas of any town have the most classic architecture. There you will find columns, archways, and more elegant settings. In the newest areas of any town, you will find more contemporary styles of architecture. Newer designs have more curved, fluid lines, and usually reflect a more informal feeling.

There are a few problems that you must deal with when incorporating architecture in your portraits. First, buildings tend to be much taller than your average client. As discussed earlier, selecting a particular lens (wide angle) can allow you to show the entire background element or isolate a portion of a scene to capture its essence (telephoto). To further control the size of background elements, you can also use the distance between the subject and background to reduce the apparent size of a very large, tall building.

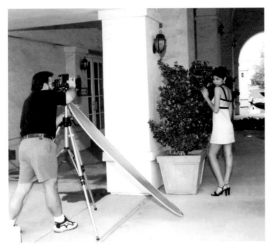

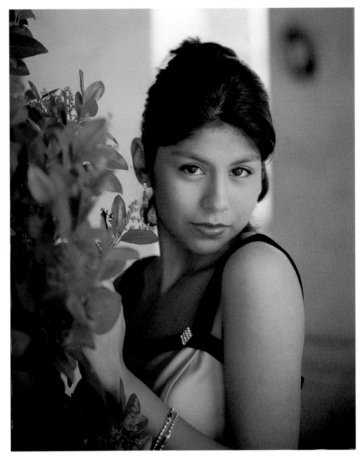

The portrait on the right makes effective use of both foliage and architectural elements, making for an interesting portrait. The photo above shows the setup. This photo was also taken on a "cloudy bright" day.

The larger and taller the building, the farther you must bring the subject away from the building. Many times we actually pose a subject across or even down the street from a larger building. To lessen the distraction of the street, as well as include a taller building, we lower the camera angle to raise the height of the background in the frame.

The Importance of Straight Lines. Another problem photographers encounter when shooting architectural scenes is remembering to keep vertical and horizontal lines vertical and horizontal. Now, I'm not talking about the distortion that takes place as you photograph a tall building from ground level and shoot straight up to the sky (the vertical lines of the building seem to get closer the farther from the camera they go). I'm talking about keeping the simple straight lines of a portrait straight

by properly adjusting the axis of the camera. This is a problem that effects young and seasoned photographers alike. I once received a collage of portraits taken by a well-known photographer who had just won an award for his images. In one of the portraits, the camera was slightly off in its alignment, making the top step of the porch the young lady was posed on not follow the bottom of the frame. This sometimes happens when you angle your shot, but this shot was taken straight on, with the vertical line of the wall and the horizontal lines of the step both slightly askew.

▶ NIGHTSCAPES

For years, photographers have used the night skyline as an interesting backdrop for portraits. I learned about this when I was very young and doing wedding photography. You

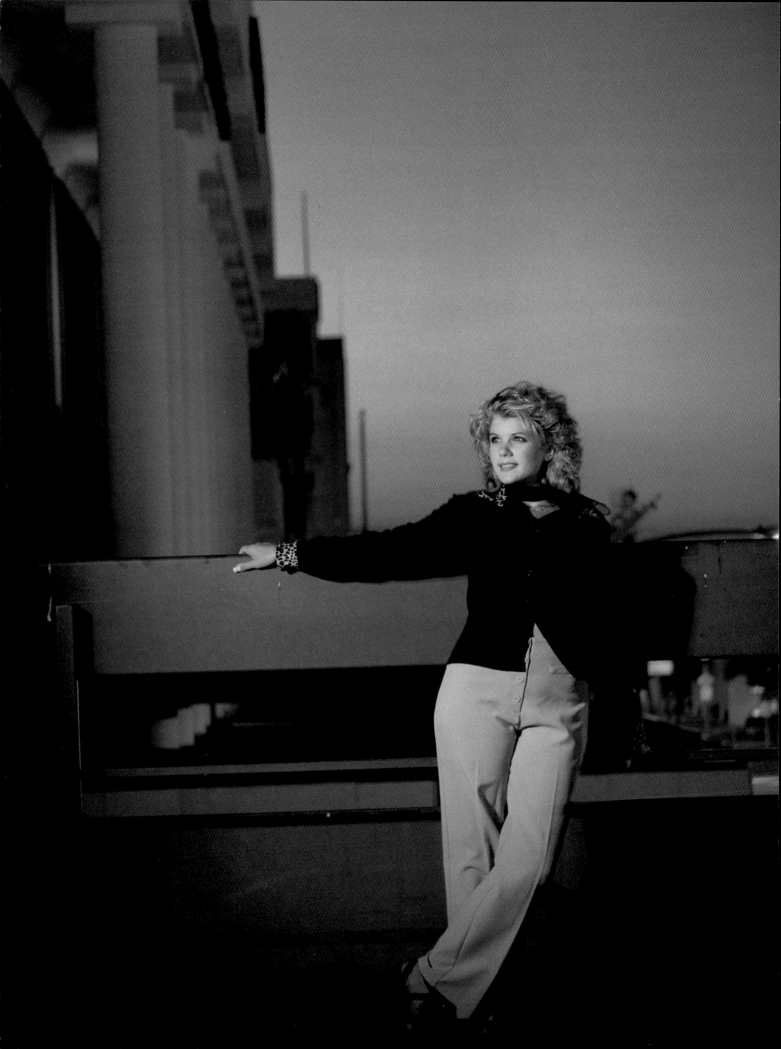

would put the bride and groom on a hill or other elevated area with the skyline (in the direction the sun just set or west) in the background. Depending on how much light was in the sky, you would either set off your flash to illuminate the couple and drag the shutter or, if it was dark enough, you would leave the shutter open so long you would actually have the couple walk out of the frame while the lens was open. I thought we could use this same technique to create interesting portraits.

Affecting Color. For the shoot, we selected a nearby river scene that gave us a nice view of the skyline, as well as the water behind the subject. I wanted the light on the subject to be warm so I put an amber gel over the main light. Now this was overkill, but I knew that if I didn't like it, the lab could print some of the amber out of the skin tone. Without any special instructions about proofing this film, the lab color corrected the skin tone, taking most of the amber out. When I received the proofs, the young lady had a beautiful skin tone and the water and skyline were an electric blue.

A bell went off. I figured that if I could change the water and background to electric blue by adding an amber gel, I could change the background and/or water to any color I wanted by selecting the opposite color of gel for the main light.

By putting a gel material over the main light source, you add color to the subject. The lab color corrects the image by adding the opposite color to the filter pack. For instance, if the gel on your main light is green, you get a magenta background. If the gel is cyan, you get a red background. You can change the background color just by putting the opposite

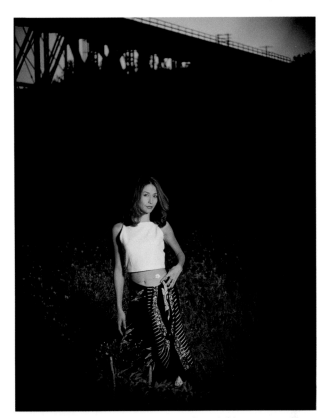

In a nightscape, you can use colored filters or gels to create interesting effects on the background. With some backgrounds, your client may need to leave the scene before the exposure is complete.

(negative) color on the main light source. You are not limited to a certain setting when using this technique. Although we selected a river with a small, sandy beach and hills in the background, this lighting technique will work well anywhere that you can see the skyline to the west. If you want a sophisticated look, use the roof or balcony of a high-rise hotel, using downtown buildings as the background. This would work better with more elegant clothing and refined tastes but, again, use common sense about safety. Bridges, hills, lakes, boxcars sitting on a railroad track can set the feeling of the portrait, while you decide what color to put behind the scene.

Facing page: For a sophisticated look, create the portrait on the roof or balcony of a high-rise hotel and use downtown buildings as the background.

This photo shows a nightscape setup. The subject is exposed by flash, and the background will expose by leaving the shutter open when the subject leaves the scene.

There are a few things you should keep in mind when taking nightscapes. First, you must use a heavy-duty tripod, a cable release, and a camera that has a "B" or Bulb setting. This is critical, since some of your exposures could last up to a minute or two. We use a single Photogenic light box, which has a diffuser panel in the front of the box that detaches to make changing main light gels much easier. A breeze usually starts toward evening, so bring weights and a heavy-duty light stand and, of course, your generator if there is no power supply.

For any exposure lasting more than eight to ten seconds, you will want to have the subject walk off the frame. Since the modeling light from the flash must be turned off, as well as any other lights that will illuminate the subject while the shutter is open, your subject will need to walk around in complete darkness. For their safety, have the client rehearse the exact path that they will take with the lights on and their eyes closed. It is best to have them repeat this until they feel confident that they can get around safely in the dark.

When employing this technique, you must look at the background that is directly behind the subject. Once the subject walks off the frame, they reveal the background in the area directly behind where they were posed. If the area behind the subject is lighter in tone than the rest of the background, this area will show through the subject. It is like double exposing an image—unless you have a black or near-black background, the two images combine. You must look for a dark element in the background that won't show through the subject, or an area that won't be illuminated by the light coming from the skyline.

After sunset, there is always a strong afterglow in the skyline. This should be metered using the reflective meter setting. Match the f-stop to the output of your flash and your meter will give you your shutter speed. As you lose this afterglow, you will get to a point that your meter can no longer read the light. At this point, you have to make an educated guess and bracket your exposures. With the incident dome on your meter, meter your flash with the gel material on, then re-meter

Facing page: When a client will walk off the scene, make sure they are posed with an obstruction or dark area behind them. In this photo, the bush behind the subject kept the reflection off the water from showing through her in the final image.

every time you change the gel material to check for changes in density.

Implementing new scene ideas like urban, architectural portraits, or nightscapes requires extra time and effort. Remember that offering something to your clients that is not available at other studios will draw business. You can also charge a higher sitting fee to make these sessions financially worth your while. Remember, too, that when there is no difference between products or services offered by competing studios, customers will book their sessions with the the studio offering the best price. When you have to compete with other studios on price you lose.

ELEMENTS OF STYLE

W hat would happen if an artist grabbed someone off the street, sat them down in a chair and, without planning or thought, began painting their portrait? Would you get a work of art? Without previsualization and planning, the portrait would be full of mistakes.

Without a clear conceptualization of what a completed work will look like, you are basically a traveler without a map.

It takes so long to complete a painting that no painter would ever start a portrait without painstakingly planning each detail of the portrait and having a crystal clear idea about how the portrait will look when it is complete. Time forces the artist to plan . . . speed encourages the photographer not to.

Our fascination with speed as photographers starts when we see commercial and fashion photographers popping off frame after frame as quickly as the flash will recycle. We start to think that speed gives us spontaneity, and that volume takes the place of planning and artistic vision.

Although fashion and commercial photographers work fast when they are photographing people, they are wizards at planning. Before they even touch the camera, they have planned the wardrobe, makeup, hairstyle, accessories, camera angles, composition, basic posing, and every other detail of the portrait. These photographers know exactly what the outcome of the session will be. Because they are working with professional models that can produce slight variations in pose and expression, they can rapidly produce many great images for their clients.

▶ **CREATING AN IMAGE WITH STYLE**

In your role as a portrait photographer, you are more like the painter than the fashion

photographer. You don't have the fashion or commercial photographer's budget to hire a stylist, set designer, assistants, coordinators, or the professional model "stand-ins" for your client to help you achieve a perfect final portrait.

Forget about the motor-drive and the "taking more frames of film is better" thinking. Imagine you are going to create five images for your client using five pieces of 8" x 10" film. You can't reshoot the session if it's bad. If you approach each session with that mind-set, you'll start to grow as a photographer. You don't need luck or the law of averages working for you.

When I was a young photographer, I noticed that many photographers produced portraits that were no better than mine. I also recognized that a few photographers created images that had a special look. Everything in the portrait seemed needed to make the portrait complete. Every color, texture, and line worked together to create a portrait that not only made the subject look good, but was a pleasure to view.

As portrait photographers, we typically think that our job is to create an image in which the client looks good. But it's not. It is to create a portrait that flatters the subject and entices a viewer's eye to focus first on the portrait and then specifically on the subject. Whether you call it coordination, style, or planning every detail of a portrait and knowing what you want the outcome to be, the mastery needed to pull off a perfect portrait is something that every photographer should strive for.

To create a portrait that your client will cherish, the basic feeling that a scene projects (from the colors, lines, texture, and lighting) must work with or coordinate with the clothing and tastes of your client. To create a portrait that is a pleasure to view, one that has that "something special" that will set it apart from an average portrait, all aspects of the portrait—the scene, hair, makeup, pose, and expression—must work together. In essence, incorporating the elements of style can make an image work. In the following sections, I will outline the elements of style and will explain how to get your client to provide you with the "materials" you need to produce the portraits they want.

Clothing. All other aspects of the portrait must be coordinated with the clothing the client has selected for the image. Clothing controls two aspects of an image: the style of the portrait (elegant, trendy, casual) and the basic color scheme of the portrait. In a perfect world, you would have scenes that were made up of the same colors as the client's clothing. This way, the focus of the portrait would be your client, not her clothing.

In the real world, photographers do not have complete control over the color that will make up the backgrounds of their outdoor portraits, and client's aren't generally interested in wearing only green or brown clothing. For this reason, we must use neutrals, which are monochromes or complementary colors. These are colors that don't match, but coordinate with the scene.

In a garden scene, which is comprised primarily of browns and greens, clothing colors

Facing page: While at the river photographing this senior, I saw the water flowing over branches and rocks and thought that it would make a interesting foreground—as well as background. To get a sufficiently low angle, I was in the water as well.

such as maroon, plum, rose, lavender, medium to dark blue and darker shades of red, will coordinate with backgrounds that are medium to dark in tone. Pastels, which are these same colors in a lighter tone, work with backgrounds that are lighter in tone.

Makeup and Hair. Most clients have a set way that they like to wear their hair and makeup and, for most of them, it works. They usually apply their makeup a little darker to go with more elegant outfits and wear lighter makeup with more casual clothing. They tend to wear their hair down with most clothing, and sometimes sweep it up for more elegant clothing or pulling it all back for very casual shots.

In the '80s, it became popular in many glamour and senior studios to have a makeup artist on staff to do each client's hair and makeup. As the '80s came to a close, clients were getting tired of the over-stylized "glamour shots" look. We have always worked with two of our area's best salons. When we refer

QUICK TIP

While variations to poses are limitless, many photographers develop a mental block when it comes to posing. At the studio, we not only look through fashion magazines each month to get ideas, but we ask our clients to clip out the poses they see in magazines that impress them. This way we have a constant flow of new ideas that are handpicked by our target market. While new posing ideas are wonderful, it is important to remember that a slight variation can be made to any pose to create many new and different poses.

The feeling that a scene reflects should determine the clothing and poses used. A formal dress is much better suited to this classic scene than jean overalls.

Left: The more the waistline is squared off to the camera, the wider it appears. **Right:** The more the waistline is turned to the shadow side of the frame, the thinner it appears.

our clients to them, they give our clients a break on the price.

Poses. The pose brings all the other aspects of the portrait together. Most photographers look to posing guides or other photographers' work to learn more on how to pose their clients. The two best sources for posing ideas are glamour and fashion magazines for more stylish and elegant poses, and watching people when they are relaxing for the more casual poses.

Typical posing guides show you what I call "mannequin poses." You see mannequins in store windows in these poses, but you will never see a real person standing or sitting in this manner. The problem is while you are studying the old world guide to posing and trying to make your clients pose like mannequins, your clients are looking at the world's

most unique images in every ad, article, magazine or newspaper they pick up.

The pose you select for your client will depend in part on their clothing, hair, makeup, and the scene in which they are posed. The purpose of the portrait and the client's taste will determine all aspects of the portrait; the pose, clothing, hair, and makeup will be different in a portrait given to a woman's boyfriend than in one given to her father, for example.

There are three types of poses: casual, which you will see in most "slice of life" ads; elegant, which you see in fashion ads; and classic, which you really don't see anywhere except at photography studios, in business portraits, or in high school yearbooks.

Casual poses are "resting" poses. You will find people in these poses when they are

There are three basic types of posing. The classic pose (above, left) is perfect for yearbook or business portraits, but has little sense of style. The casual pose (above, right) is the slice of life pose. A glamorous pose (left) is used for impact.

watching television or talking with a friend. The head is often resting on the hands, arms, or shoulders. Elbows can rest on the knees, or prop the body up when laying on the floor. The body is either reclining or leaning forward to rest on the knees or ground. Casual poses are perfect when the portrait is being given to a parent or family member. Families want to see natural, comfortable poses that resemble the way the families see the subject each day. Elegant poses are more dramatic. Impact is the sole purpose of these poses. Casual poses have the hands and arms in logical positions (supporting the head, for example) where elegant poses have the hands and arms posed to add impact to the image. They are posed to add interesting lines or fill the composition to heighten the visual impact.

In most cases, elegant or stylish poses are designed to make the subject attractive. These poses make a woman look like a woman and a man look manly. Whether the clothing is an evening gown or a swimsuit, a tux or a Speedo®, the elegant pose is designed to flatter the human form.

▶ CORRECTIVE POSING BASICS

Incorporating certain elements in any posing style will help improve the appearance of your client in the final image. Keep in mind that posing a subject so that their waistline is squared off to the camera creates the appearance of a wider waistline. The more the waistline is turned to the shadow side of the frame, the thinner it looks, which is a definite plus. When you have a person sit down, the hips

Above: When everything in a pose works together, the resulting portrait truly has a special look. **Facing page:** Anytime a client has an issue with his or her weight, poses that show as little of the body as possible should be used. Foreground elements like this twisted branch can be used to hide problem areas from view.

and thighs mushroom out. By having the subject roll over on the hip that is closest to the camera, the hips and thighs will appear to be thinner.

While I have included only a couple of tips, there are many posing techniques that can be used to improve a client's appearance. For a comprehensive treatment of the subject, you may wish to refer to my recent book, *Corrective Lighting and Posing Techniques for Portrait Photographers* (Amherst Media, 2001).

It is only when every component of a pose works that the portrait will have that special look. When the pose you have selected flatters your subject, and every possible distraction has been eliminated, the viewer can sit back and enjoy the fruits of your labor. As mentioned earlier, an ability to plan a shot is what separates portrait artists from photographers.

▶ **CLIENT COOPERATION**

All this talk about art and coordination sounds good, but how do you get the client to cooperate? For years, every speaker or lecturer in photography has suggested using consultations to find out what the clients want from their sessions, and to inform them about the steps they need to take to get the image they want. The problem is that talk is cheap. You can talk with clients for an hour and they will still end up doing what they want rather than what you need them to do to achieve the portraits they have in mind.

The first goal of a consultation, whether you do it in person or have a consultation

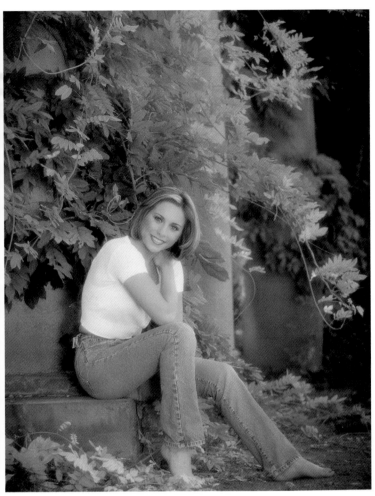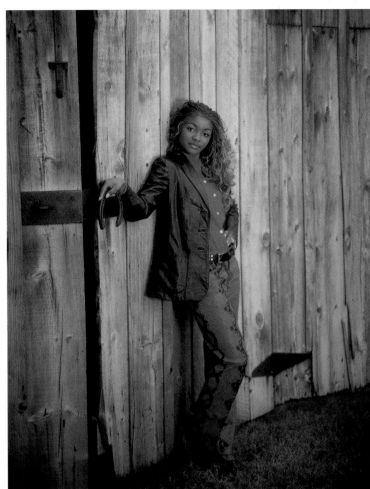

Above and facing page: A client's consultation session provides the perfect opportunity for photographers to describe the client's role in determining the outcome of his or her portrait. Taking the time to help clients prepare for their session helps ensure pleasing results.

video (which is what we use because of the volume of clients we have), is to make clients aware that they are largely responsible for the outcome of their session. You have to be very blunt, yet tactful, and explain that you won't be responsible for the outcome of the session if they don't follow the suggestions you are giving them.

We work with several thousand seniors and the first question that almost every one of them asks is, "What happens if I don't like my portraits?" I tell them I will be explaining exactly what to do to prepare for the session and what clothing to bring in for the type of

portraits they want. I tell them that they should arrive twenty minutes before the session begins to select the backgrounds and poses they want done. I then explain that the only time someone is unhappy with their portraits is when they don't follow the suggestions that I give them and, in that case, they would have to pay for another session.

Once your clients recognize their responsibility for the outcome of their session you can concentrate on your part, which is creating the type of work that all of us aspire to. Until you get cooperation from your clients, you will struggle with the problems that arise from

a client's lack of preparation for a session. How many times have you had a woman come in, with arms like a tree trunk and nothing but sleeveless tops? When she see the proofs she says, "Well, they are nice, but my arms look big!" "I want to retake these, and next time I want my arms to look smaller!"

Most problems that arise when dealing with clients in any business are caused by a lack of communication. The consultation should not only prepare clients for their session, but can solve most of your business problems as well. What we do is sit down with our staff and talk about our clients. We ask the staff what the clients are complaining about. We then ask our staff what their complaints are about the clients. We list the complaints from both sides and then figure out what information the client or studio didn't get that caused these problems to occur. Once we figure out what information they didn't get about us or we didn't get about them, we incorporate a discussion of that particular topic into the consultation video to eliminate the problem.

Trust is the key to a successful session. When you take the time to help clients properly prepare for their session, it builds trust in your business. They see that you are not just out to get into their pockets, but that you truly care about creating the best portrait possible.

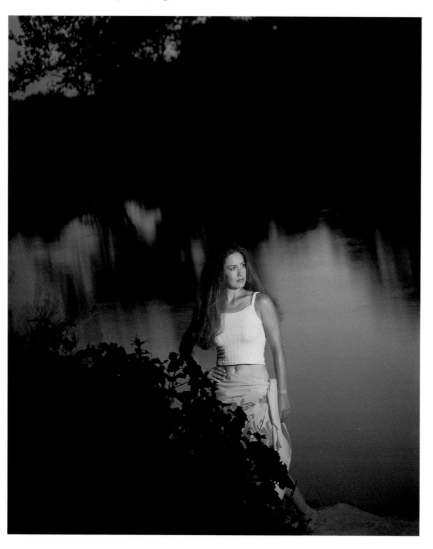

While scenic portraits like these are always a favorite of photographers, many clients feel that the subject appears too small in the frame. It is important to talk with your client before the session so you have an idea of what is right for them.

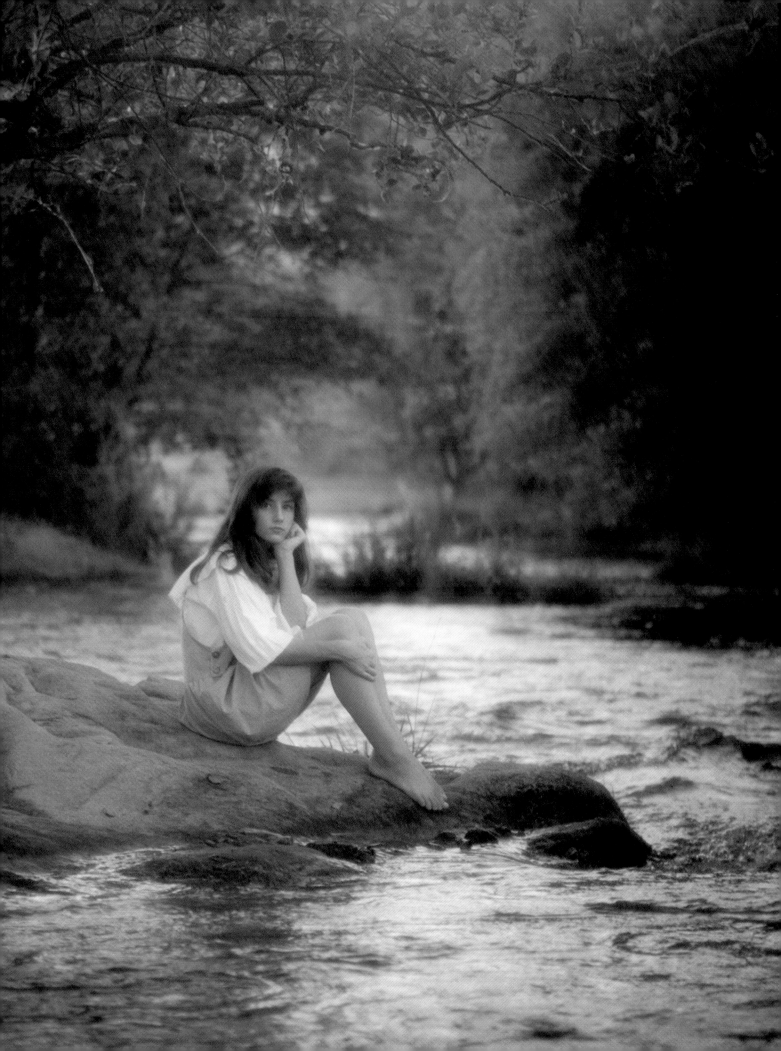

CHAPTER 7

MAXIMIZING PROFIT

The majority of this book is dedicated to the art of photography, because that's what photographers most want to learn. In the last two chapters, we will discuss the business side of photography, because that is what most photographers need to learn.

All photographers are artists at heart. Unfortunately, most artists die in poverty. In a profession that brings its practitioners the potential to earn a great deal of money, the average yearly income is well below the poverty line. Believe it or not, the art of photography will not save you. There are very talented photographers that can't make a living in their professions. Talent is the cheapest commodity known to man. I can hire a trained photographer to work for my studio for less money per hour than a union janitor makes—a lot less.

If you look at the library of any young photographer you know where the problem lies. While you will see countless books on photography and maybe even art theory, you typically won't see any books on business, advertis-

ing, or marketing. We dedicate years to developing our talent, but how do we take this talent and turn it into a business that allows us to live the life we want?

Look in the phone book under photographers and there will be rows of photographers listed just under the portrait heading. At least half of those names won't appear in the phone book five years from now. That is the reality of the photography business.

In any given city, there are probably only few studios that provide their owners a lifestyle equal to that of other professionals in their community. The majority of studios, however, provide an income that is equal to or less than an average union worker, and the union worker has benefits! Most photogra-

phers simply can't afford retirement plans and insurance packages.

In a competitive market, the "open your business doors and they will come" philosophy won't cut it. Even doctors are advertising nowadays to build their practice. If you don't have a plan to get clients into your studio (marketing) and know how to handle their sessions properly (making a profit), yours will be one of those names not found in the phone book five years from now.

The '80s saw a frenzy of marketing education for portrait studio owners. You couldn't swing a stick without hitting a speaker or lecturer spouting their philosophies on the subject of marketing, and this continues today. While a solid marketing plan will undoubtedly draw clients in, profiting from each session should be the cornerstone of your business plan.

▶ NO PROFIT, NO PORTRAITS

Forget about photography for a minute, and concentrate on this: without profit, you have no money for anything—no money to buy film, mailers, or anything else that will help you to support your marketing plan. Profit is the most important aspect of your business.

There are two types of profitable studios. The first is devoted to "high end" portrait work. These studios cater to few clients and charge an enormous amount for what they do. This is the type of studio that all of us hope to have. In reality, however, few of these studios can exist and profit because there aren't many clients who have that kind of money and put that high a value on portraiture. The second kind of profitable studio is one like ours. These studios charge a competitive price and work with a larger volume of clients. The dif-

ference between these two types lies in the ratio of hours worked to profits earned.

The Bottom Line. Breaking down a very complex formula, to be successful (earning a profit), you, as the photographer, must generate at least $300 an hour when you are working with a client. In other words, if you spend an hour with a client, their order should be at least $300. If you spend six hours with a client, (planning their session, traveling, photographing, and selling) the order should be approximately $1800. If your average is more than this, you probably work with fewer clients per month and have more free time. If your average is lower than this, you need to attract more clients to earn a living and will probably run around like a crazy person.

This is a ballpark figure—there are many factors that may increase or decrease your profit and how much per hour you must generate. You may work out of your home with a very limited staff, which would allow you a greater profit margin. On the other hand, your studio may be in a mall or more exclusive area, which increases your costs and decreases profit, thereby increasing the amount you must generate per hour.

This is one of the reasons so many photographers find wedding photography so unprofitable. You have several meetings with the couple, spend seven hours at the wedding, two hours taking the order, and three hours putting the album together. Generating $300 per hour for the many hours spent with a couple is difficult at best. When most photographers shift their focus from cash flow to profit they see that shooting weddings doesn't produce enough profit.

I have heard photographers talk about two options in increasing their profit margins:

raise prices or decrease costs. I want to talk about a third option. It's one that photographers hate, but it has been adapted in almost every other profession—increasing your productivity. In our profession, as in any other, this means working with more than one client at a time.

▶ MAXIMIZING PRODUCTIVITY

I know what you are thinking. A minute ago I was telling you to think like an artist, to plan every detail and know the outcome of a portrait before you create it. Now I am telling you to work with two or three people at a time! That is exactly what I am telling you to do. Photographers sell themselves (and their abilities) short. They think it's impossible to be both good and fast. Being able to make decisions that go into the creation of a portrait doesn't take a great deal of time once you know what you are doing, it's just that most photographers allow themselves to think too slowly.

Most photographers waste up to 50 percent of their time waiting. Once you have decided on a scene, how long does it take to actually pose someone and snap off two to three photographs? You then send them back to change their clothing and wait for their return or rush along, not allowing them to change their clothing at all.

By working with two clients at a time, you don't waste time waiting. Clients may have to wait a few minutes after they are done changing, but that doesn't effect your profit. And for those who think that your clients won't tolerate waiting, think about the last time you went to a restaurant on a Friday or Saturday night, or took a trip to a doctor's or dentist's office. You waited your turn and didn't say a thing about it. You realized that this was a professional or, in the case of a restaurant, a popular business, and the waiting seemed normal.

Let me offer a couple of tips on working with multiple clients: First, you need to start planning ahead. You need to think about the area you are currently photographing in, and instruct the second client to wear something that would be appropriate for that area. This saves you the time of running from one side of a location to the other. Second, ask the clients to come to the area where you are working once they have changed. Instruct them not to watch the person being photographed as it might make that person nervous.

My studio specializes in senior portraits. This is a very competitive area of professional photography. Outdoor photography is something that is not offered by every studio that caters to seniors and, as it sets our studio apart, we advertise the fact that outdoor portraits can be made at no extra charge. If we added a fee for the ability to go to an outdoor location, most seniors wouldn't do it. This means they wouldn't take portraits that they would love to have and I wouldn't enjoy the additional sales that these sessions bring to the studio.

To offer outdoor sessions without charging for travel, we knew we had to schedule blocks of appointments on certain days at certain locations. Because of the size of our studio, we have devoted entire days to outdoor sessions. If your studio produces a smaller volume of

Facing page: Sometimes a client doesn't need to be posed. Often, while I am working with one client, another client has a chance to just relax and enjoy the natural surroundings. If you are observant, you can record some of the most natural portraits you have ever seen.

work, you can schedule three or four sessions in a single morning or afternoon. This way the time spent in transit is "spent" only once, and results in several sessions. That said, you can see that it is feasible to offer these outdoor sessions without charging additional fees for the service—and you can still increase your profit.

We offer our seniors several options that help them get the most out of their sessions. This includes not only the potential for outdoor locations, but black & white photos, including a friend, a car, motorcycle, etc. This sounds counterproductive when looking at profitability. I could charge a small fee for each of these options and increase my profit margin, right? Wrong. I would have fewer clients taking advantage of these options and I would lose a great deal of money. The more you can do to make a client's session unique and provide them with options other studios don't, the better your sales average will be.

▶ **SALES AVERAGES**

Many studio owners talk about sales averages. They take all their orders for the month and divide it by the number of people who ordered. That isn't sales averages. For your sales average to have any merit, you have to take your total sales and divide that by the total number of clients you photographed, whether they bought portraits or not.

Consider this: If you have only one client order for the year, their $5000 order seems to make for a great sales average, but since that was the only client that ordered, your business might be in trouble. A true sales average

can make you aware of business problems before you have to close your doors. If you have a high number of clients not ordering, you are obviously doing something wrong. In this position, most photographers would assume the problem is either their photography or their clients. Most of the time it's neither.

The way you run your business has more to do with the money you have in your pocket (profit) than your photography or the clients you work with. Most photography studios offer the exact same services, and almost the same level of quality, to their clients. When you study your business to try to figure out the ways in which you can increase your profit margin, take a close look at the policies and practices of your business and the image of your studio. After all, it is the client's perception of a business that determines whether that business succeeds or fails.

It is impossible to cover all of the tips and techniques photographers can employ to increase their business and profits in this book. Let me offer a very important bit of advice: Invest in some books on business and/or enroll in some business courses. They will help you increase your profit. There is no limit to the money that can be earned in this profession. Always remember the sole function of your business is to make a profit, and it is only when your business makes the profit necessary for you to live the life you expect that you can truly enjoy creating the product you sell.

Facing page: Offering sessions at the beach has turned out to be a source of additional profit for both of our studios. We have many clients come from our main studio (in Fresno, California) to our Monterey studio location, just to have beach portraits taken. It's a two-hour drive, so they make a day of it.

CHAPTER 8

MARKETING OUTDOOR PHOTOGRAPHY

Now that you have given some thought to making money, you can focus your attention on getting clients through the door. The golden rule of marketing is this: when a product or service offered by a business is no different from that offered by a competitor, a client will choose a business based solely on price. In other words, you have to use price as the greatest motivating factor to get the potential client to come to your business, and not your competitor's. In marketing, this is called promotion.

Some promotions are effective. It makes good business sense to run a special to increase cash flow during a slow time of year. Using promotion as the sole element of a marketing strategy, however, starts a downward spiral of the value of your product/service. If you don't believe this, ask yourself how long it has been since you paid full retail price for a pair of jeans. Most stores regularly have sales on all major brands of jeans. They have the holiday sales, super sales, clearance sales and Saturday only sales. Anyone who doesn't have an immediate need for an item simply waits until a store has a sale on that particular product.

By offering your clients quality outdoor portraiture, you have something unique to market, especially if you don't charge an additional fee for that service. The current focus in most senior studios has been to offer stylish studio portraits with a countless variety of backgrounds, sets, and/or projection backgrounds. While my studio offers seniors over 260 backgrounds in the studio, we concentrate most of our advertising on outdoor portraiture because it is unique to our studio. No one else in our area that I know of offers seniors the ability to go to a scenic location without charging a very large sitting fee.

▶ GETTING THE MESSAGE OUT

The message is a sort of summary that states why a client should solicit your studio above any other. It is the theme of your advertising that ties all of your advertising together. Major advertisers are masters at this. Your message should tell potential clients what makes your studio unique. By using one message or theme in your marketing plan, name recognition is achieved much quicker.

Most studios never tie their marketing ideas together with a common theme. With the limited budget of most photographers, the studio or photographer's name is never recognized by potential clients. To tie together a marketing plan, many advertisers not only develop a common message or theme to their advertising, but also come up with a slogan—very few words that sum up your message.

Ensuring that all of your marketing materials are made with a similar design—everything from business cards, to stationary, to mailers—should help to create name recognition for your business. If you produce radio spots, you should use the same voices, but not those of the DJ's of the station. Listeners are used to those voices, and the DJ's familiar voice is easy to ignore. The more you can do to ensure that your various advertising messages have the same basic feeling, the easier it will be for the average client to remember your studio's name.

▶ PUSHING YOUR STUDIO'S IMAGE

Your studio's image is another important consideration in a marketing plan. Is your studio more prestigious or more budget-oriented? What type of clients do you work with the most? What type of clients do you want to draw in?

Ideally, every photographer would have the money to sit down and figure out what type of portraiture they want to specialize in. They would design everything to appeal to that type of client. Every choice, from location, to furnishings, to colors, to the staff, to the music played in the studio, to the marketing materials would be carefully selected for a specific clientele. Unfortunately, not too many photographers start their business with that kind of money or forethought.

The image you portray in your marketing plan must be the true image of your studio. If you operate a one-hour lab with an express portrait service, your image is quite different from a carriage trade studio. Should you send out an elegant mailer, showing large canvas portraits proudly and elegantly displayed in very prestigious homes? The image the client would receive would be a far cry from the reality. This advertising would do you no good. When the potential client pulled up in front of your lab/studio, she would feel like you betrayed her because the image the mailer portrayed didn't accurately depict the image of your studio.

Your studio's image is revealed to your clients in every aspect of your business, from the style and color scheme of your business cards to the way you or your receptionist answers the phone. Whether you work out of your home or have a prestigious studio, every part of your marketing plan should visually represent your studio's true image. The most successful businesses, whether they are low volume, high profit, or high volume, are successful because their marketing plan hasn't only gotten them a certain number of responses, but has provided them with a good number of potential clients.

There is a difference. As a business, you can't appeal to everyone. If your marketing doesn't target just "your market," you end up with a great number of phone calls and/or visitors that will discover that they have no interest in what you are selling. If my studio bought a general mailing list, rather than one with the names of seniors only, I might waste 90 percent of my time explaining that the studio does only senior portraits.

▶ **ADVERTISING OR MARKETING?**

Advertising and marketing are two different things. Marketing is everything you do as a business owner to raise the awareness of your business in the minds of your target market, from handing out a business card to asking for a referral. Advertising is a "paid for" message, increasing public awareness of your business.

There are many studios that rely on a marketing plan that has no advertising in it. Between word of mouth, referrals, exhibits, and free sessions, they are satisfied with the amount of new business they generate. Typically, however, most businesses get to a point that fresh new clients are needed. Word of mouth and referrals help get clients, but they are client's friends and sooner or later, everyone in a client's circle of friends will know of you and no new business will be generated.

▶ **ADVERTISING ESSENTIALS**

While word of mouth and referrals basically cost you nothing, advertising is far from free. No matter what means you use to advertise, it's all expensive. Whether it's direct mail,

radio, television, the yellow pages, or buying ads in programs, it's very easy to spend $1000 just getting started.

Most photographers don't have a clue about advertising. In fact, some advertising people don't know that much more. A famous advertising man by the name of Ogilvy said that he figures that about half of all the advertising he creates actually works and if he could just figure out which half it was, he would have something. Although I don't have all the answers, I have studied a great deal on the subject of advertising and I will share with you some of what I have learned.

Since advertising is so expensive, you must target your advertising message to the people that have an interest in what you are selling. While using your own database to advertise will get you the best response for advertising dollars spent, you will not generate any new clients to your current client list. This means you must look outside your circle of current clients.

Targeting your market really isn't that difficult. First, you must define your average client. Who are they? What is their age? What is their income level? Is the person who decides to hire you a woman or a man, a mother or father, a parent or a senior? Once you figure all this out, you then find the most efficient means to reach only those types of people.

Direct Marketing. Direct marketing, which is typically based on direct mail, is usually the advertising of choice. Direct mail's evil twin, telemarketing, is used by some, but it has such a bad reputation, it might effect the

Facing page: When you create portraits that are unique—that your clients don't see at every other studio—you have something to market. If you don't have anything unique to market, it all comes down to price.

image of the business that uses it. If you don't believe it, ask yourself if you would ever buy anything a telemarketer was selling. I know I wouldn't.

Mass Advertising. Radio, television, and newspaper are considered mass advertising, which is basically advertising aimed at the masses. If you have a chain of stores in a certain area, are part of a franchise, or have an incredibly diverse appeal, then mass advertising is for you. This type of advertising is for those businesses that don't have a real target market—their market is basically everyone. McDonalds, grocery stores, home stores, etc., have a mass appeal. Their client base is any person who eats or has a home. Typically, these types of businesses are large enough to have the necessary budget for this type of advertising.

Knowing this, why on earth do you see photographers using this type of advertising? Ego. I have to admit, it is cool seeing your ad on television or hearing it on the radio. I did both before I had any real idea of how to advertise. When I was at the grocery store one day, a little girl said, "Hey mommy, that's a man I saw on TV!" I thought it was the coolest thing. Although this little girl remembered me, I couldn't track one client that came from these ads.

Radio is the only type of mass advertising that I have heard anything positive about. Some photographers have told me they have had great success in using a combination of radio and direct mail for a special promotion. The problem is that most photographers call a radio salesperson who tries to sell a package of advertising. This package includes both spots when people are actually listening and spots when all but the insomniacs are asleep.

Another problem with mass advertising is that, on the average, a person must hear/see your advertising message at least five times before they will remember it and call you when they have a need. To make these five impressions in mass advertising, you have to run a countless number of advertisements. What nobody will tell you is that most people use commercial breaks to go to the bathroom or see what song is playing on another station. Most newspapers are large, and the chance that your ad will be seen there really isn't any better. Basically, reaching your clients in this way is a shot in the dark. And every shot will cost you $100 to $1500. It doesn't take long to see why so many photographers stick to direct mail.

The Yellow Pages. Word for word, advertising in the yellow pages is probably the most expensive advertising you will ever buy. Some photographers say they get a great deal of business from these ads. I don't feel they are worth what they are charging. Most yellow page shoppers shop price. They are looking for the easiest and cheapest way to get a product or service. They go from ad to ad calling and asking how much it is for what they want. I do this all the time. When I need an electrician, plumber, or exterminator, I go from ad to ad comparing the prices, and the best price gets the job.

Obviously, if you are the cheapest photographer in your area, the yellow pages might be the best way to advertise. There is a catch-22 here, though—if you are, in fact, the cheapest studio in your area, you probably can't afford a display ad in the yellow pages. So it's probably better to look for another way to get clients into your business.

▶ DESIGNING MAILERS

Since the most effective way to advertise is by direct means, which translates into direct mail, we need to talk about how to design these mailers. Because direct mail is so popular in our profession, clients receive a glut of mailers from local photographers and, unfortunately, they pretty much look the same. Just like in your business, if the images you show are not unique enough from the other images that potential clients see, you will not make a lasting impression.

In senior portraiture, the amount of mailers that any given senior receives is amazing. This last year, we offered a $5.00 discount for each mailer that the seniors brought in from other studios. We did this to see the variety of mailers that the average senior gets in the course of the year. I was amazed. Luckily, we had the forethought to put a limit on the number they could turn in, which was ten.

As I looked at all the mailers that we received, I saw that ego rather than common sense prevailed when many of these photographers designed their mailers. Each photographer's mailer had a similar design, similar size, and a simple slogan on the front like, "Senior Style," "Hot Summer, Cool Prices" and a few other gems that mean more to the designer of the mailer than they do to the receiver.

Each photographer felt that their images alone would set their mailer apart from all the others. I am a trained professional photographer. I looked at the various images, trying to determine who created the nicest images. To tell you the honest truth, they pretty much all looked the same. There were differences in background, poses, and subjects, but all of them were about the same quality. If I, a professional photographer, couldn't see that much of a difference in the images, what difference would an untrained, half-interested senior or parent see?

Mailers should contain four specific elements, each of which has a specific purpose. First, you have the headline, which is the most important part of a mailer—yes, more important than the images. Then you have the images that you include as samples of your work. The third part of a mailer is the body, which is the part of the mailer that makes the sale or, in this case, gives the reader the desire to pick up the phone. Finally, you have the close, or the call to action. Ask any salesperson and they will tell you, without a close, there isn't a sale.

The Headline. The Headline either makes a statement or asks a question that can only be answered by reading the text. If your headline doesn't entice the viewer of your mailer to become a reader of your mailer, your advertising will have little effect. The viewer will simply look at the pretty pictures and throw it in the pile of other advertising they probably won't get back to.

The longer you can keep a mailer in the hands of a potential client once they pick it up, the greater the impact you make. Since clients repeatedly asked us if the people we use in our advertising are models, we employed the answer as a headline—"No, They're *Not* Professional Models . . . They Just Look Like They Are!" The body of the mailer explained the steps we take to ensure that each of our clients look great. Another headline we used for outdoor portraits was, "Outdoor Portraits Cost You Nothing!" This obvious overstatement was designed to entice the viewer to read the mailer to see if outdoor

portraits are really free or just the ability of doing outdoor portraits is free. The body of the mailer explained that while most studios charge ridiculously high sitting fees to take portraits outside of the studio, our studio would do it for free.

A headline that poses a question is another way to entice a viewer. A headline that worked well for us was, "Do *you* know the difference between a *picture* and a *portrait*?" Then the body explained how we plan and create our portraiture.

No matter what type of headline you use, a good headline can increase your response rate dramatically. Without a headline, your mailer is just another piece of advertising with pretty pictures.

The Images. The images are an important part of a mailer. After all, it is what you do. The images draw attention to the mailer and that's it. Images won't get a viewer to read about your studio or increase the likelihood the viewer will pick up the phone and call. The images need to support the headline and body of the mailer. The portraits need to be out of the ordinary to draw attention to the mailer. Don't try to promote outdoor portraiture using a subject leaning up against a tree. This is a very common outdoor shot that will not garner much attention from any potential clients as they have seen this type of portrait many times.

The biggest question that arises about the images is whether to do them in black & white or color. Years ago, four-color printing was so expensive that very little of it was used, so it was very unique. Although color printing is still expensive, the price has lowered enough that most photography studios use it, so it is no longer unique. People have always said that, in advertising, color images have a better response rate on the average than black & white. While this is true, the increase in response rate doesn't offset the increase in cost between color and black & white. This and the fact that quality black & white images are considered to be more unique than color make black & white mailers an intelligent choice for the photographer on a budget. When I talk about using black & white mailers, notice I said *quality* black & white. This doesn't mean you fire up your computer for the layout and then have some paper half tones done to paste on. Quality black & white means that you go to a larger printer and have plates made. This produces a near photographic quality image that is still much less expensive than color.

The Body. The body of the mailer is where you explain the headline. This is where you present the reasons why the viewer of the mailer should come to your studio rather than the studio down the street. The content of the body should be as brief as possible, yet long enough to explain all the unique opportunities that your studio offers. The body can be comprised of a list of your unique services, or can be written in paragraph form. Unless you are a great writer that can keep a person hanging on your every word, consider using a list, as it tends to be easier to read.

The Close. The close is basically a call to action. Now that you have seen the images we create and have read the reasons why you

Facing page: As you select images for a piece of advertising, be sure to show different styles. While this portrait would appeal to a younger woman, it probably wouldn't be a favorite of a mother or grandmother. Select images that appeal to your predominant decision maker, but that reflect the variety of work you offer.

should come to our studio, get up off your duff and pick up the phone. Of course, that's not what you write, but this is the end result that you want. For example, use one of the following statements after the body of the mailer: "Call for Your Appointment Today"; "Call Now—Before the Beautiful Colors of Spring Are Just a Memory"; or "Call Today—Appointments Are Limited."

There are a countless number of reasons why readers should pick up the phone and call, you just need to make them sound somewhat pressing so they don't forget to do just that. Some photographers might think it is corny, but some direct mailers reward the first ten or twenty appointments scheduled with additional poses taken in their session. This makes an excellent close. Remember, without a close, most sales won't take place.

The Logo. I'd mentioned that there are four components to a mailer. There is, however, one more thing that is important—your logo. A logo doesn't have to be a design done by a graphic artist that includes a camera or other artwork attempting to make it unique. The most important word in direct mail is readability. If a person can't easily read what you've printed, they won't read it at all.

Years ago, a senior brought a mailer with a photograph that he wanted me to duplicate for him. After I studied the portrait, I looked to see what studio the mailer was from. I looked at least thirty seconds for any kind of return address or logo, and I'm not exaggerating. Finally, way down in the bottom third of the back of the mailer was a very delicate, very artsy logo. The logo had white type on a black background, which made it very hard to read. This studio took all the steps to get someone to pick up the phone, then made it almost impossible to find the studio name or phone number. They shot themselves in both feet.

Have your printer typeset your logo in the normal return address position in a bold, easy to read typestyle. Don't add cameras, film strips, or grape leaves—your name, address, phone number, and website and e-mail address (if applicable), business hours, and a map to the studio will do. Make it as easy as possible for a potential client to reach your studio. If the mailer is difficult to read or comprehend, your phone will never ring.

Getting Your Mailers to the Public. To purchase a mailing list, just look up marketing in the yellow pages. There should be several companies that sell them. Talk with each of them about what lists they have and how well they are working. Once you find a list that sounds like it would be made up of your target market, you can further target your market by asking for a certain income level, age, or sex. In our case, we found that about 85 percent of the seniors that came to us as a result of our marketing were girls. We also realized that we were buying lists made up just seniors, half of which were boys. So to get the most of our advertising dollar, we asked for a mailing list with only senior girls.

These lists are really terrific. If your purchase the list on a disk you can run your own labels, or, if you prefer, you can order labels that are preprinted with your target audience's names.

When you start planning your advertising, remember that it takes five impressions before a potential client will call. It stands to reason that you would have a much better response out of 5000 mailers by designing three to five mailers and getting three to five sets of labels, as opposed to one set of 5000 labels for a sin-

gle mailing. I say three to five sets because sending out five mailings to potential clients may be overkill if they have already been reached through another part of your marketing plan.

▶ GIVING YOUR WORK AWAY

When I first opened my studio, I went to seminar after seminar, reading book after book that explained the way a given photographer was conducting their business at that particular point in their career. But my career was not yet at the level that theirs was. They would go on and on about all the glorious and expensive ways they conducted their business, but they didn't talk about how they got to that point. It was like they were giving me the destination without providing a map or guide for the trip along the way.

At this point in my career, I spend thousands of dollars a year marketing my business, but I can afford to. If you are just starting out, you may find it hard to pay your existing bills. In the section about mailers, I recommended that those on a tight budget have their mailers printed in black & white. I explained that it costs much less and would allow the photographer to run as many copies as his or her budget would allow. Fortunately, there are many other low-cost ideas that can be effectively employed to help you build your business.

By far the least expensive and most effective means to get business is to basically give your work away. I am not talking about lowering your price or working for nothing on a large scale. I am talking about strategically selecting persons that you feel could benefit your business by being in the right circles and vocal enough to be an advocate for your stu-

dio. This is something that I started when I just opened my studio and continue to use today.

When I opened my studio, I, like most new studios, worked with any type of client that walked through the door. After a few months in business, I found that families, although they were harder to photograph, brought in more money to the studio than any other type of client. Needing money desperately, I started looking for a family that I could photograph and get a wall portrait up in their home. When I was photographing a wedding, I talked with a lady that seemed to have many friends and traveled in the circles that could afford nice portraiture.

I set up a time with her for the session. We photographed her family at a nice outdoor location. We told her for doing this for us we would give her the set of proofs. When she viewed the proofs, she decided to place an order, but didn't want to purchase a wall portrait, which was my plan. The order was sizable enough that I told her that for advertising purposes, I would have a 16" x 20" portrait made, free of charge, as long as she agreed to display it in her home. I also asked her not to tell anyone that I had given her this portrait, and told her the price of the portrait so she could tell her friends if they asked. As a result of this one session, I photographed twelve other families over the next thirteen months. This definitely helped pay the rent at a time that I might not have been able to without these sessions.

Probably the most effective and the cheapest means of getting your name to your target market is what most labs call PR wallets. Most labs offer these wallets in sets of 100 and they produce a litho to go over the negative. On the

litho you put your studio name and phone number (you can also add your address, website, and/or e-mail address if you wish). You can give these wallets to any client you feel is outgoing enough to give them away. And unlike normal wallets, these wallets have your name right on the front so everyone who looks at it knows you created it. It works with weddings, seniors, children, or families and for about $13 for 100 wallets, you can't go wrong.

If this option appeals to you, there are a few things you should keep in mind. You should be the one to select the poses that a client can select from. Look for the most unique poses and backgrounds—an image that would attract someone's attention. Don't select poses that are too revealing or could be embarrassing if they were seen by anyone other than the subject's significant other, or the wallets will end up in a desk drawer rather than a potential client's hand.

Offer to make these wallets for your client after he or she places his or her order so as not to effect your income. If you work with a particular type of clientele, ask this client to give the majority of the wallets to people who make up your target market. In our case, we photograph juniors in high school at the end of the school year and have these wallets made for them. We ask them to give these wallets to others in their class. We realize a number of the wallets go to family, teachers, and friends not in their class, but it's still a reasonably effective marketing tool to help gain name recognition for you and your studio.

There are many ways to get your name out before your target market. If you don't have the money to pay for advertising, then you have to use your imagination. It all works out—if you don't have the money, you have a great deal of time on your hands to think of these ideas. As your business grows, you end up having more money than time, so you pay for your advertising.

Facing page: If you decide to give away free wallets or a wall portrait for a client's home, make sure to explain that you will help in selecting the pose. An ordinary pose or boring background won't get you the kind of response you are looking for.

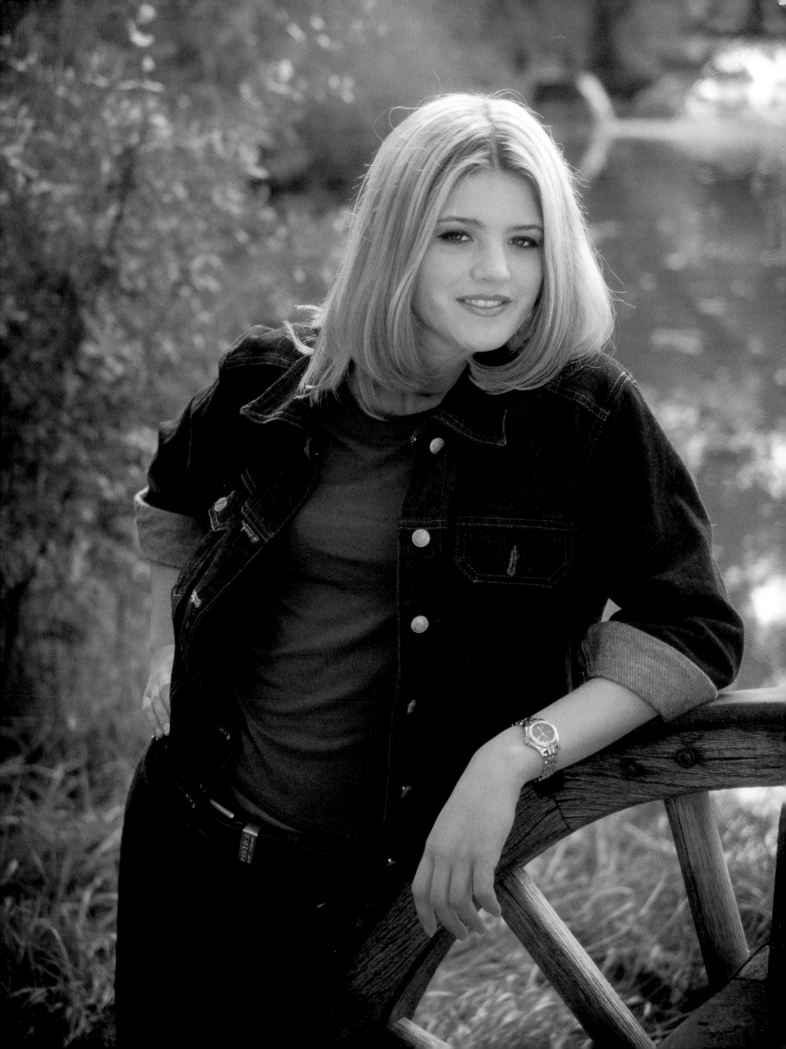

CONCLUSION

Every journey begins with a single step, each career starts off with a single idea. When we start in this profession, photography consumes our lives. As we grow, many of us lose our passion for our art. My father used to tell me, "As long as a man thinks of himself as green, he is growing. It's only when he considers himself grown that he begins to die." Passion is the driving force of this profession and once photographers lose their passion, this exciting profession becomes a job and nothing creative can be produced from a job. Portraits start to turn to photographs, the excitement of new ideas is replaced by fear of change.

Success isn't arriving at a certain point, but the journey along the way. Some photographers allow their lives to be consumed by this profession. You can achieve a great deal of success in this business, but unless you achieve a balance of a successful life and a successful business, you won't enjoy any of what success can bring you. It's like I tell people, "I love my work, but photography is what I do, my family is who I am."

I wish you luck in your journey. I hope you find the path that leads to the success you are looking for.

RESOURCES

This section provides contact information for companies whose products are mentioned in this book.

▶ **CANON**
www.usa.canon.com
Toll Free US: (800) OK-Canon

▶ **FUJI**
www.fujifilm.com

▶ **LIGHTFORM**
www.bogenphoto.com

▶ **NIKON**
www.nikonusa.com

▶ **LINDAHL**
www.lslindahl.com
4800 Quebec Avenue North
New Hope, MN 55428
Toll Free US: (800) 787-8078
(763) 537-3601
Fax (763) 537-2852

▶ **PHOTOFLEX**
www.photoflex.com
Photoflex Inc.
97 Hangar Way
Watsonville, CA 95076
(800) 486-2674

▶ **SINGH-RAY**
www.singh-ray.com
Toll Free US: (800) 486-5501
(863) 993-4100

INDEX

Other Books from
Amherst Media

Also by Jeff Smith . . .

Corrective Lighting and Posing Techniques for Portrait Photographers

Bring out the best in your clients through effective lighting and posing strategies for flattering portraits. $29.95 list, 8½x11, 128p, 100 full color photos, index, Smith. (ISBN 1-58428-034-4) Order no. 1711

FEATURES:
- Evaluating your client's problem areas
- Utilizing corrective lighting to optimize your subject's overall appearance
- How to address your concerns with tact and professionalism
- How to adapt poses to hide flaws, like a double chin or tummy bulge

Wedding Photographer's Handbook

Robert and Sheila Hurth

A complete step-by-step guide to succeeding in the world of wedding photography. Packed with shooting tips, equipment lists, must-get photo lists, business strategies, and much more! $29.95 list, 8½x11, 176p, index, 100 b&w and color photos, diagrams, order no. 1485.

Lighting Techniques for Photographers

Norman Kerr

This book teaches you to predict the effects of light in the final image. It covers the interplay of light qualities, as well as color compensation and manipulation of light and shadow. $29.95 list, 8½x11, 120p, 150+ color and b&w photos, index, order no. 1564.

Lighting for People Photography, *2nd Edition*

Stephen Crain

The up-to-date guide to lighting. Includes: set-ups, equipment information, strobe and natural lighting, and much more! Features diagrams, illustrations, and exercises for practicing the techniques discussed in each chapter. $29.95 list, 8½x11, 120p, 80 b&w and color photos, glossary, index, order no. 1296.

Infrared Photography Handbook

Laurie White

Covers black and white infrared photography: focus, lenses, film loading, film speed rating, batch testing, paper stocks, and filters. Black & white photos illustrate how IR film reacts. $29.95 list, 8½x11, 104p, 50 b&w photos, charts & diagrams, order no. 1419.

Wedding Photography:
CREATIVE TECHNIQUES FOR LIGHTING AND POSING, *2nd Edition*

Rick Ferro

Creative techniques for lighting and posing wedding portraits that will set your work apart from the competition. Covers every phase of wedding photography. $29.95 list, 8½x11, 128p, full-color photos, index, order no. 1649.

How to Operate a Successful Photo Portrait Studio

John Giolas

Combines photographic techniques with practical business information to create a complete guide book for anyone interested in developing a portrait photography business (or improving an existing business). $29.95 list, 8½x11, 120p, 120 photos, index, order no. 1579.

Creating World-Class Photography

Ernst Wildi

Learn how any photographer can create technically flawless photos. Features techniques for eliminating technical flaws in all types of photos—from portraits to landscapes. Includes the Zone System, digital imaging, and much more. $29.95 list, 8½x11, 128p, 120 color photos, index, order no. 1718.

Black & White Portrait Photography

Helen T. Boursier

Make money with b&w portrait photography. Learn from top b&w shooters! Studio and location techniques, with tips on preparing your subjects, selecting settings and wardrobe, lab techniques, and more! $29.95 list, 8½x11, 128p, 130+ photos, index, order no. 1626

Profitable Portrait Photography

Roger Berg

A step-by-step guide to making money in portrait photography. Combines information on portrait photography with detailed business plans to form a comprehensive manual for starting or improving your business. $29.95 list, 8½x11, 104p, 100 photos, index, order no. 1570.

Professional Secrets for Photographing Children
2nd Edition

Douglas Allen Box

Covers every aspect of photographing children on location and in the studio. Prepare children and parents for the shoot, select the right clothes capture a child's personality, and shoot storybook themes. $29.95 list, 8½x11, 128p, 80 full-color photos, index, order no. 1635.

Family Portrait Photography

Helen Boursier

Learn from professionals how to operate a successful portrait studio. Includes: marketing family portraits, advertising, working with clients, posing, lighting, and selection of equipment. Includes images from a variety of top portrait shooters. $29.95 list, 8½x11, 120p, 123 photos, index, order no. 1629.

The Art of Infrared Photography, *4th Edition*

Joe Paduano

A practical guide to the art of infrared photography. Tells what to expect and how to control results. Includes: anticipating effects, color infrared, digital infrared, using filters, focusing, developing, printing, handcoloring, toning, and more! $29.95 list, 8½x11, 112p, 70 photos, order no. 1052

Photographer's Guide to Polaroid Transfer
2nd Edition

Christopher Grey

Step-by-step instructions make it easy to master Polaroid transfer and emulsion lift-off techniques and add new dimensions to your photographic imaging. Fully illustrated every step of the way to ensure good results the very first time! $29.95 list, 8½x11, 128p, 50 full-color photos, order no. 1653.

Wedding Photojournalism

Andy Marcus

Learn the art of creating dramatic unposed wedding portraits. Working through the wedding from start to finish you'll learn where to be, what to look for and how to capture it on film. A hot technique for contemporary wedding albums! $29.95 list, 8½x11, 128p, b&w, over 50 photos, order no. 1656.

Professional Secrets of Wedding Photography

Douglas Allen Box

Over fifty top-quality portraits are individually analyzed to teach you the art of professional wedding portraiture. Lighting diagrams, posing information and technical specs are included for every image. $29.95 list, 8½x11, 128p, order no. 1658.

Photo Retouching with Adobe® Photoshop®

Gwen Lute

Designed for photographers, this manual teaches every phase of the process, from scanning to final output. Learn to restore damaged photos, correct imperfections, create realistic composite images and correct for dazzling color. $29.95 list, 8½x11, 120p, 60+ photos, order no. 1660.

Creative Lighting Techniques for Studio Photographers

Dave Montizambert

Master studio lighting and gain complete creative control over your images. Whether you are shooting portraits, cars, tabletop or any other subject, Dave Montizambert teaches you the skills you need to confidently create with light. $29.95 list, 8½x11, 120p, 80+ photos, order no. 1666.

Storytelling Wedding Photography

Barbara Box

Barbara and her husband shoot as a team at weddings. Here, she shows you how to create outstanding candids (which are her specialty), and combine them with formal portraits (her husband's specialty) to create a unique wedding album. $29.95 list, 8½x11, 128p, 60 b&w photos, order no. 1667.

Fine Art Children's Photography

Doris Carol Doyle and Ian Doyle

Learn to create fine art portraits of children in black & white. Included is information on: posing, lighting for studio portraits, shooting on location, clothing selection, working with kids and parents, and much more! $29.95 list, 8½x11, 128p, 60 photos, order no. 1668.

Infrared Portrait Photography

Richard Beitzel

Discover the unique beauty of infrared portraits, and learn to create them yourself. Included is information on: shooting with infrared, selecting subjects and settings, filtration, lighting, and much more! $29.95 list, 8½x11, 128p, 60 b&w photos, order no. 1669.

Marketing and Selling Black & White Portrait Photography

Helen T. Boursier

A complete manual for adding b&w portraits to the products you offer clients (or offering exclusively b&w photography). Learn how to attract clients and deliver the portraits that will keep them coming back. $29.95 list, 8½x11, 128p, 50+ photos, order no. 1677.

Composition Techniques from a Master Photographer

Ernst Wildi

In photography, composition can make the difference between dull and dazzling. Master photographer Ernst Wildi teaches you his techniques for evaluating subjects and composing powerful images in this beautiful full-color book. $29.95 list, 8½x11, 128p, 100+ full-color photos, order no. 1685.

Innovative Techniques for Wedding Photography

David Neil Arndt

Spice up your wedding photography (and attract new clients) with dozens of creative techniques from top-notch professional wedding photographers! $29.95 list, 8½x11, 120p, 60 photos, order no. 1684.

Infrared Wedding Photography

Patrick Rice, Barbara Rice & Travis Hill

Step-by-step techniques for adding the dreamy look of black & white infrared to your wedding portraiture. Capture the fantasy of the wedding with unique ethereal portraits your clients will love! $29.95 list, 8½x11, 128p, 60 images, order no. 1681.

Photographing Children in Black & White

Helen T. Boursier

Learn the techniques professionals use to capture classic portraits of children (of all ages) in black & white. Discover posing, shooting, lighting and marketing techniques for black & white portraiture in the studio or on location. $29.95 list, 8½x11, 128p, 100 photos, order no. 1676.

Dramatic Black & White Photography
SHOOTING AND DARKROOM TECHNIQUES

J.D. Hayward

Create dramatic fine-art images and portraits with the master b&w techniques in this book. From outstanding lighting techniques to top-notch, creative darkroom work, this book takes b&w to the next level! $29.95 list, 8½x11, 128p, order no. 1687.

Posing and Lighting Techniques for Studio Photographers

J.J. Allen

Master the skills you need to create beautiful lighting for portraits of any subject. Posing techniques for flattering, classic images help turn every portrait into a work of art. $29.95 list, 8½x11, 120p, 125 full-color photos, order no. 1697.

Studio Portrait Photography in Black & White

David Derex

From concept to presentation, you'll learn how to select clothes, create beautiful lighting, prop and pose top-quality black & white portraits in the studio. $29.95 list, 8½x11, 128p, 70 photos, order no. 1689.

Watercolor Portrait Photography
THE ART OF POLAROID SX-70 MANIPULATION

Helen T. Boursier

Create one-of-a-kind images with this surprisingly easy artistic technique. $29.95 list, 8½x11, 128p, 200+ color photos, order no. 1698.

Basic Digital Photography

Ron Eggers

Step-by-step text and clear explanations teach you how to select and use all types of digital cameras. Learn all the basics with no-nonsense, easy to follow text designed to bring even true novices up to speed quickly and easily. $17.95 list, 8½x11, 80p, 40 b&w photos, order no. 1701.

Make-Up Techniques for Photography

Cliff Hollenbeck

Step-by-step text paired with photographic illustrations teach you the art of photographic make-up. Learn to make every portrait subject look his or her best with great styling techniques for black & white or color photography. $29.95 list, 8½x11, 120p, 80 full-color photos, order no. 1704.

Professional Secrets of Natural Light Portrait Photography

Douglas Allen Box

Learn to utilize natural light to create inexpensive and hassle-free portraiture. Beautifully illustrated with detailed instructions on equipment, setting selection and posing. $29.95 list, 8½x11, 128p, 80 full-color photos, order no. 1706.

Portrait Photographer's Handbook

Bill Hurter

Bill Hurter has compiled a step-by-step guide to portraiture that easily leads the reader through all phases of portrait photography. This book will be an asset to experienced photographers and beginners alike. $29.95 list, 8½x11, 128p, full color, 60 photos, order no. 1708.

Basic Scanning Guide For Photographers and Creative Types

Rob Sheppard

This how-to manual is an easy-to-read, hands on workbook that offers practical knowledge of scanning. It also includes excellent sections on the mechanics of scanning and scanner selection. $17.95 list, 8½x11, 96p, 80 photos, order no. 1708.

Professional Marketing & Selling Techniques for Wedding Photographers

Jeff Hawkins and Kathleen Hawkins

Learn the business of successful wedding photography. Includes consultations, direct mail, print advertising, internet marketing and much more. $29.95 list, 8½x11, 128p, 80 photos, order no. 1712.

Photographers and Their Studios
CREATING AN EFFICIENT AND PROFITABLE WORKSPACE

Helen T. Boursier

Tour the studios of working professionals, and learn their creative solutions for common problems, as well as how they optimized their studios for maximum sales. $29.95 list, 8½x11, 128p, 100 photos, order no. 1713.

Traditional Photographic Effects with Adobe Photoshop

Michelle Perkins and Paul Grant

Use Photoshop to enhance your photos with handcoloring, vignettes, soft focus and much more. Every technique contains step-by-step instructions for easy learning. $29.95 list, 8½x11, 128p, 150 photos, order no. 1721.

Master Posing Guide for Portrait Photographers

J. D. Wacker

Learn the techniques you need to pose single portrait subjects, couples and groups for studio or location portraits. Includes techniques for photographing weddings, teams, children, special events and much more. $29.95 list, 8½x11, 128p, 80 photos, order no. 1722.

The Art of Color Infrared Photography

Steven H. Begleiter

Color infrared photography will open the doors to an entirely new and exciting photographic world. This exhaustive book shows readers how to previsualize the scene and get the results they want. $29.95 list, 8½x11, 128p, 80 full-color photos, order no. 1728.

High Impact Portrait Photography

CREATIVE TECHNIQUES FOR DRAMATIC, FASHION-INSPIRED PORTRAITS

Lori Brystan

Learn how to create the high-end, fashion-inspired portraits your clients will love. Features posing, alternative processing and much more. $29.95 list, 8½x11, 128p, 60 full-color photos, order no. 1725.

The Art of Bridal Portrait Photography

Marty Seefer

Learn to give every client your best and create timeless images that are sure to become family heirlooms. Seefer takes readers through every step of the bridal shoot, ensuring flawless results. $29.95 list, 8½x11, 128p, 70 full-color photos, order no. 1730.

Photographer's Filter Handbook

Stan Sholik and Ron Eggers

Take control of your photography with the tips offered in this book! This comprehensive volume teaches readers how to color-balance images, correct contrast problems, create special effects and more. $29.95 list, 8½x11, 128p, 100 full-color photos, order no. 1731.

Beginner's Guide to Adobe® Photoshop®

Michelle Perkins

Learn the skills you need to effectively make your images look their best, create original artwork or add unique effects to almost image. All topics are presented in short, easy-to-digest sections that will boost confidence and ensure outstanding images. $29.95 list, 8½x11, 128p, 150 full-color photos, order no. 1732.

More Photo Books Are Available

Contact us for a FREE catalog:
AMHERST MEDIA
PO BOX 586
AMHERST, NY 14226 USA

www.AmherstMedia.com

Ordering & Sales Information:

INDIVIDUALS: If possible, purchase books from an Amherst Media retailer. Write to us for the dealer nearest you. To order direct, send a check or money order with a note listing the books you want and your shipping address. Freight charges for first book are $4.00 (delivery to US), $7.00 (delivery to Canada/Mexico) and $9.00 (all others). Add $1.00 for each additional book. Visa and MasterCard accepted. New York state residents add 8% sales tax.

DEALERS, DISTRIBUTORS & COLLEGES: Write, call or fax to place orders. For price information, contact Amherst Media or an Amherst Media sales representative. Net 30 days.

1(800)622-3278 or (716)874-4450
FAX: (716)874-4508

All prices, publication dates, and specifications are subject to change without notice.

Prices are in U.S. dollars. Payment in U.S. funds only.